IMAGES
of America

NIPOMO AND LOS BERROS

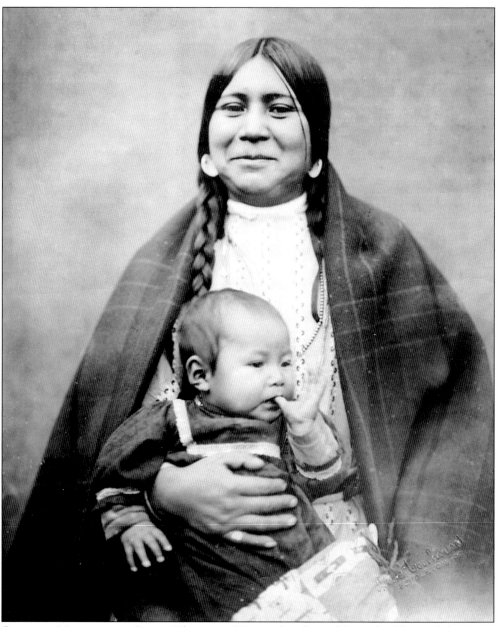

CHUMASH MOTHER AND CHILD. The name "Nipomo" is derived from the Chumash language meaning "at the foot of the hills," which is a fairly accurate description given the prominence of the hills in the area. A Chumash mother and child living near Cuyama are the subjects of this photograph taken around 1880. The local Chumash tribe played an integral role in the development of the region from its beginnings. (Courtesy History Center of SLO County.)

ON THE COVER: Hans and Andrew Mehlschau immigrated to the United States from Germany. In 1884, the two began a joint venture in the wheat industry in Nipomo that lasted until 1908. Here, a harvesting crew and their nine-horse team are pictured with the iconic hills in the background. (Courtesy History Center of SLO County.)

IMAGES
of America

NIPOMO AND LOS BERROS

Doug Jenzen

ARCADIA
PUBLISHING

Published by Arcadia Publishing
Charleston, South Carolina

Printed in the United States of America

Library of Congress Control Number: 2011937399

For all general information, please contact Arcadia Publishing:
Telephone 843-853-2070
Fax 843-853-0044
E-mail sales@arcadiapublishing.com
For customer service and orders:
Toll-Free 1-888-313-2665

Visit us on the Internet at www.arcadiapublishing.com

*This book is dedicated to all of the residents of Nipomo
and Los Berros—past, present, and future*

CONTENTS

FOREWORD

Capt. William G. Dana's Nipomo Rancho and the community that evolved on the 37,000-acre Mexican land grant are central to the history of our state.

In December 1846, Dana's famed herd of California mustangs saved Col. John C. Frémont's Battalion of Mounted Rifles (California Battalion) from disaster. Without the extra mounts, Frémont could not have proceeded over the San Marcos Pass and recaptured Santa Barbara. That event led Mexican general Andres Pico to surrender to Frémont at the Capitulation of Cahuenga on January 14, 1847.

By mid-1848, the adobe became the "turn around point" for the military government's mail system. Mail was brought from Monterey and points north to the adobe where couriers would take it onto Los Angeles and points south. Later, the adobe ranch house became a stagecoach stop along the coast route. But the Dana Rancho's most important role was as a college of law.

Henry Amos Tefft, a New York-born attorney from Racine, Wisconsin, arrived at the Dana Adobe in 1849. His ship to San Francisco had been forced to take refuge in Southern California. He stayed at the adobe for three months. Through his conversations with Captain Dana, Tefft became familiar with Spanish-Mexican legal traditions.

Tefft went to Monterey in August 1849, one of the first 10 delegates to be seated at the California Constitutional Convention in Monterey's Colton Hall. He was appointed secretary pro tempore of the convention and served on committees that decided how the constitution would be drafted and how many delegates from each area would be seated.

On September 27, 1849, a committee for the convention introduced the following "Miscellaneous Provisions" to the section: "All property both real and personal, of the wife, owned or claimed by her before marriage, and acquired afterwards by gift, devise or descent, shall be her separate property, and laws shall be passed more clearly defining the rights of the wife in relation as well as to her separate property as that held in common with her husband."

The chief advocate of this farsighted approach to women's status was Henry Tefft, who cited California's existing Hispanic laws that guaranteed native California women separate property rights.

The Dana Adobe had served Tefft far better than any existing college of law might have done. Tefft drowned in a seaboard accident in 1852, but his legacy was formalized in the California Constitution of 1849, which was presented for statehood. It is truly a unique event in the history of civil rights for women. It was renewed in the California Constitution of 1879.

During the 1880s, the Nipomo region saw the coming of the narrow gage Pacific Coast Railway and early efforts at subdivision. The introduction of specialized crop agriculture promoted the development of Nipomo's own regional economy. It is famed as a center of pole-bean production that led to the importation of migrant labor.

In 1936, Dorothea Lange, a photographer working for what was then the Resettlement Administration, "saw and approached the hungry and desperate mother, as if drawn by a magnet."

In *Popular Photography* (published in February 1960), she continues: "I do not remember how I explained my presence or my camera to her, but I do remember she asked me no questions. I made five exposures, working closer and closer from the same direction. I did not ask her name or her history. She told me her age, that she was thirty-two. She said that they had been living on frozen vegetables from the surrounding fields, and birds that the children killed. She had just sold the tires from her car to buy food. There she sat in that lean- to tent with her children huddled around her, and seemed to know that my pictures might help her, and so she helped me. There was a sort of equality about it."

The images that Lange made of Florence Owens Thompson and her children in February or March of 1936 in Nipomo, California, moved a nation. The "Migrant Mother" prints have been subject to much speculation and reinterpretation by philosophers and historians alike. Lange's 1960 memorialization is only part of the story. But the images remain arguably one of the most famous in the history of photography.

Doug Jenzen's excellent compilation of photographs and text fully depicts the evolution of a community from rancho days to the hard times when the migrant schools struggled to meet the needs of the Dust Bowl refugees. They followed the circuit of California agriculture from the Imperial Valley through Nipomo and on to the orchards of San Benito and Santa Clara counties, the Sacramento Valley. Finally, cotton harvesting began in Kern County, but it only started the circuit again.

Today's Nipomo is a product of that historical evolution. I rejoice to see the community join together to recreate that vital history.

—Dan Krieger
Professor Emeritus of History
California Polytechnic University, San Luis Obispo

President
California Mission Studies Association

ACKNOWLEDGMENTS

There are many people whom I would like to express my heartfelt gratitude for helping complete this project. First, I would like to thank Erin Newman from the History Center of San Luis Obispo County. With her help, the idea of a book about Nipomo came to life after expressing concern over the future of the few historical structures that remain in Nipomo. She has been an advocate throughout the arduous task of writing this book and extremely helpful with the logistics of my first publication. Erin and the rest of the staff at the History Center of San Luis Obispo County have been an amazing help, and I highly recommend visiting them to research local history.

I am also extremely grateful for the help of Marina Washburn with the Dana Adobe Nipomo Amigos (DANA). Marina was extremely helpful with photograph acquisition (the most arduous part of this project), making contacts in the community, and publicity. She has allowed me to interrupt her daily schedule on more than one occasion to chat about this project when she probably had many other tasks she needed to complete. The DANA is an exceptional organization and has amazing volunteers that are dedicated to the restoration of the Dana-Carrillo home and the preservation of the surrounding open space. Working on this book, I have come to realize that the history of Nipomo is interconnected with the Dana Adobe, which demonstrates why it is extremely important to preserve this piece of heritage.

There are many other individuals and organizations that I want to thank for their contributions: Mr. and Mrs. Homer Fox with the Nipomo Community Presbyterian Church, the Amezcua family, Susan Gray and Colleen Beck with DANA, Dave Flynn with the San Luis Obispo County Department of Public Works, Jerry Knotts and his family, Kanani Fox with the Guadalupe-Nipomo Dunes Center, Denise Goodwin, Marge Baker and her family, Dave Duran with the Nipomo Men's Club, Dr. Dan Krieger, Jackie Gracia, Paula Carr with Caltrans, Gary Hoving and Ross Kongable of the South County Historical Society, Janelle Bledsoe of Nipomo's Chamber of Commerce, Peg Miller, Hal and Maria Zornes Baker, and Coleen Balent with Arcadia Publishing. Without the time, information, and images donated by these individuals, this book would have been incomplete.

One hundred percent of the author proceeds earned from this book will benefit DANA and their continued restoration efforts.

INTRODUCTION

Rancho Nipomo once encompassed the vast majority of land between what is now known as Arroyo Grande and the Santa Maria River—an area blessed by rich soil and natural resources that enabled the establishment of towns whose economy was based in agriculture and natural resource extraction. The original land grant was awarded to William G. Dana and his family by the Mexican government in 1837 and encompassed the Nipomo and Los Berros region. The area's history is significant not merely because of the history that took place within its boundaries but also because of its relationship with distant places. The movement of goods and people is what connected Nipomo and its vicinity to the world and made it an extremely dynamic location to live.

However, before the Danas began settling the area, its history had already begun with the Chumash people. Nipomo's name has origins in the Chumash language, meaning "at the foot of the hills." The first drawing of the area shows circles in the Nipomo valley, possibly indicating locations of Native American settlements in the region. The Chumash people also played a major role in the later development of the region when William Goodwin Dana employed them. They helped to clear the land to make it suitable for agriculture, build the house that the Danas lived in beginning in 1839, and arguably established a precedent for later waves of laborers that came from Europe, China, Japan, the Philippines, and Mexico.

The Danas changed the physical and social landscape of the region by participating in a worldwide trade network that spanned from the Pacific and beyond. William Dana, being a trader himself, extracted natural resources from the surrounding environment to ship to distant places. When he moved to California, otter fur was his emphasis until the animal became nearly extinct. Upon arriving in Rancho Nipomo, the Danas and their laborers raised enormous quantities of cattle. They primarily used the cattle for their hides and tallow, which they shipped out of Port Hartford (now Port San Luis) to New England and elsewhere. There, the leather and tallow became part of the industrial revolution when factories transformed it into goods, such as shoes, soap, and candles. The family used their profit to order goods, such as clothing, food, and alcohol, which were manufactured in faraway cities. Even today, it is difficult not to come across a piece of porcelain or glassware produced in 19th-century China or England while walking around the grounds of the Dana Adobe. Businessmen made fortunes whenever boomtowns developed in places such as San Francisco, and they morphed into centralized locations where goods could easily be imported and exported to and from rural areas such as Nipomo. Pieces of Nipomo became part of the 19th-century globalized trade network by way of these cities, while foreign goods found a new home in the town. The region became enmeshed in the world economy.

As the Dana family grew, they were increasingly involved with trade and politics. John C. Frémont stayed at Rancho Nipomo during the Mexican-American War—the conflict in which the United States gained control of California and much of the Southwest. The Dana family gave Frémont and his troops supplies for their trip to Santa Barbara. Following American annexation, Dana's first son-in-law, Henry Amos Tefft, was a delegate to the state's constitutional convention while many

of Dana's sons participated in local politics. By 1860, while his brothers were participating in local politics, Jose Ramon Dana was driving cattle to the San Francisco Bay Area to be sold to Henry Miller—part of Miller and Lux Corporation that revolutionized the meat industry and turned it into the West Coast's version of the factory system, which was growing in New England.

The children of William Goodwin and Maria Josefa Dana began subdividing the original property as they reached adulthood. William Charles Dana was the first to do so when he married Modesta Maria Castro and moved to Los Berros (meaning "the watercress") in 1861. The two built their own adobe home that still stands today. Other Dana children built their homes closer to the original Dana Adobe. When the Pacific Coast Railway extended its route from San Luis Obispo to the Santa Ynez Valley in 1882, the company built stations in Los Berros and Nipomo. The Dana family began selling plots of land the same year, and the town of Nipomo developed. Los Berros also had a small housing tract develop but never grew to the same extent as its neighboring town.

The introduction of transportation dramatically transformed the region. The Pacific Coast Railway enabled the movement of people and goods to and from the area during the turn of the century. Speculators planted thousands of eucalyptus trees around the Nipomo and Los Berros area, reportedly making it one of the largest stands of eucalyptus trees outside of Australia. Businessmen from Los Angeles developed quarries in Los Berros, while agriculturalists experimented with various crops around Nipomo that they shipped out of the region via railroad. These developing industries required labor. Initially immigrants from around Europe and China arrived and took up odd jobs, but by the turn of the century, racism and exclusionary immigration laws meant that Japanese immigrants were the main labor force in the Nipomo area. Federal immigration reform in 1924 essentially banned immigration into the United States, which left farmers scrambling for labor. The same decade saw the agricultural industry boom as cars became more readily available to transport goods and people, and roads along the California coast were improved. Each of which added to an increased labor need. Filipino immigrants found themselves filling the labor void, as the Philippines was a possession of the United States at the time and bypassed the newly created immigration laws. These immigrants worked in the fields and built the roads through Nipomo and the Central Coast and have left a legacy still seen in the Filipino community today.

Perhaps the most famous aspect of the region's history is that which was created by the photographer Dorothea Lange. The economic hardship of the Great Depression and the environmental catastrophe of the Dustbowl caused by improper farming and affected coastal California unlike any other region. Thousands of immigrants made their way to the state looking for work in the fields. They followed the crops north and south, as they were ready for harvest at different times in the various geographic regions. Many found themselves in Nipomo and Los Berros, hoping to find work in the region's pea fields. Unfortunately, weather was not on the side of the migrants when frost killed the pea crop each year throughout the 1930s. Without an income, these immigrants were left stranded. Dorothea Lange captured many of these migrants on film and brought attention to the need for government intervention to help them. She unintentionally gave a face to an entire generation of people. Today, Lange's "Migrant Mother" appears in many US history textbooks as an example of the struggles society faced during the Depression.

Working through the hardships of the Great Depression, the postwar era saw a period of normalcy for the Nipomo area. The nation's economy gradually improved and this allowed an influx of new residents to the area. More houses were built for the new residents, and local organizations and businesses were formed. At first glance, it appears that the postwar era saw population booms and enormous change; however, regardless of advancement, the local population always maintains ties with its rancho-style past that began with the Dana family.

One

THE DANA FAMILY

Early Nipomo and Los Berros represent a period where Spanish, Mexican, and American history intersected each other. Once on the rural frontier of the Spanish Empire and then on the fringe of the Mexican nation, Nipomo's story begins with the Chumash people, whom many believe had settlements in the region.

Nipomo was connected with the rest of the world when the Dana-Carrillo family settled the region during the 1830s. Dana came from a prominent New England family with roots in Colonial America. However, with the death of his parents at an early age, he found himself orphaned and working as a sailor aboard ships taking part in the Pacific Trade Network. This experience left him traveling and moving supplies in Asia, Hawaii, and Alaska. Eventually, Dana moved to Santa Barbara in 1825, where he opened a store and partook in the otter industry. Eventually, Dana turned to the cattle industry when the dwindling otter population declined due to overhunting.

Dana was part of a political movement in 19th-century Mexico. The Mexican government wanted to draw settlers from the United States in an effort to convert its self-sustaining rural mission settlements to centers of agriculture and trade. The government secularized all mission lands and transferred them to private owners. All one had to do was swear allegiance to the Mexican government, convert to Catholicism, and learn Spanish to qualify for the newly liberated and fertile mission-land holdings. Dana was a benefactor of this program. Once he was in Nipomo, he utilized his vast land holdings to raise cattle for export, and his hides supported the New England industry as well as the local Mexican economy.

Behind Dana's success were many laborers. Native Americans built the Dana-Carrillo home based on popular New England architecture but utilized locally available products, such as adobe, wood, leather, and tar. The Dana Adobe represents an amalgamation of Mexican, American, and Native American ingenuity. Today, the home stands as a monument to multiculturalism, and a place with many different meanings to many different people.

DANA ADOBE, C. 1880. This photograph shows unidentified people standing in the front of the Dana Adobe. This view is commonly mistaken for the back. The white clapboard room towards the left of the house is believed to have been added by Fred Dana during the 1880s and was used as a bathroom. When the house was originally built, the technology did not exist to create an attached commode. The family not only utilized the Dana Adobe as a house but also as a store and a place where goods were manufactured. The adobe was also used as a connecting point on the state's first postal route. The Dana-Carrillo family and their laborers created goods, such as flour, soap, candles, brandy, lard, and cornmeal. They produced goods for sustenance, long-distance trade, and gifts for travelers that stopped by the home. (Courtesy DANA.)

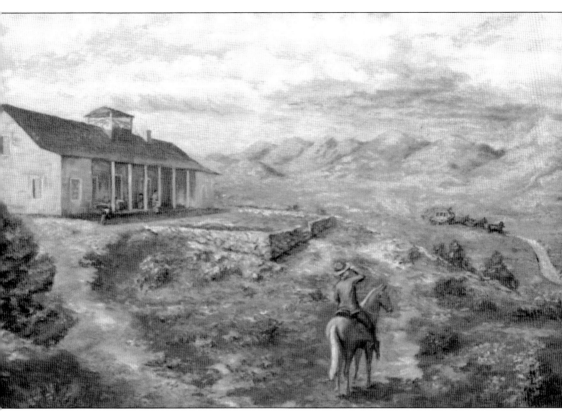

FRANCES MEAD JENSEN PAINTING. Frances Mead Jensen painted this romanticized version of the Dana Adobe in 1929. It shows the peace and tranquility surrounding the rancho. The Old Stagecoach Road that was located near the home is also visible. The Dana's hospitality was well known among travelers on the road who ran between San Francisco and Los Angeles. (Courtesy DANA.)

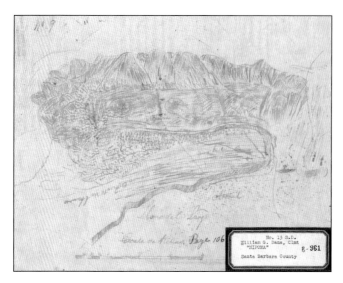

DISEÑO DEL RANCHO NIPOMO. This is the first drawing that shows the land granted to Dana by the Mexican government. Its creation date is estimated to be during the 1840s, around the time the United States expressed interest in the annexation of California. When the United States acquired California from Mexico in 1848, all Mexican land-grant recipients had to file ownership claims with the federal government (Courtesy Bancroft Library, University of California, Berkeley.)

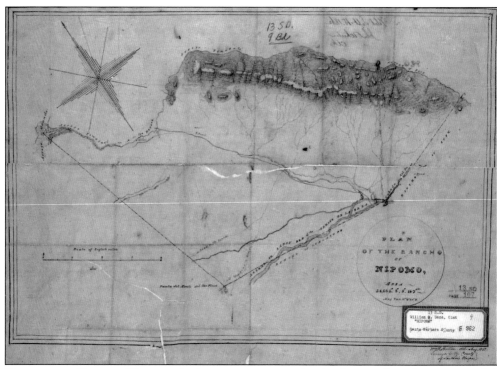

PLAN OF THE RANCHO NIPOMO. As the court cases proving land ownership claims proceeded through the United States court system, more accurate maps were produced. San Luis Obispo County surveyor William Rich Hutton, for whom there is a road named today, created this map in 1850. The Dana house is marked near the center of the map. There is also a road leading to Guadalupe, mirroring today's Division Street. (Courtesy Bancroft Library, University of California, Berkeley.)

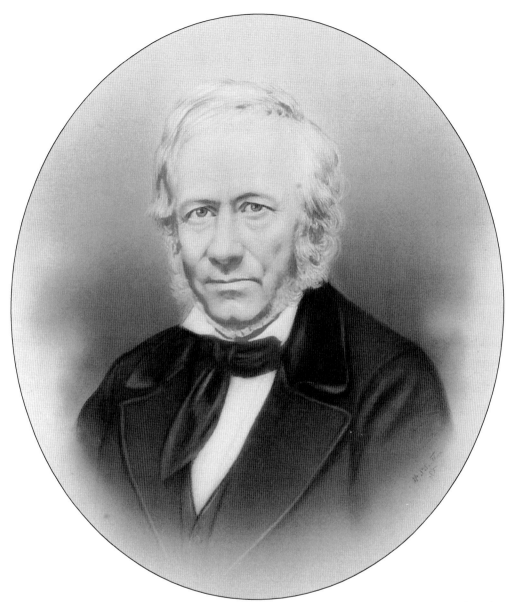

CAPT. WILLIAM GOODWIN DANA. Born in 1797 in Boston, Dana eventually relocated to the Mexican frontier, a land that would become Nipomo. Men like Dana found themselves in Mexico to take advantage of expanding markets and resources but found that personal and business success required adjustment to the local culture and circumstances. His land grant contained an estimated 38,000 to 50,000 acres. Dana participated in the otter-fur trade and allowed other local prominent citizens to utilize his hunting license for which he received a percent of the profit. As the animal's population dwindled, he turned to cattle ranching for the leather trade. Dana and his family were self-sufficient and generated enough hide surpluses to maintain a warehouse in Port San Luis, from which he shipped his hides and tallow to destinations around the Pacific and along the East Coast. (Courtesy DANA.)

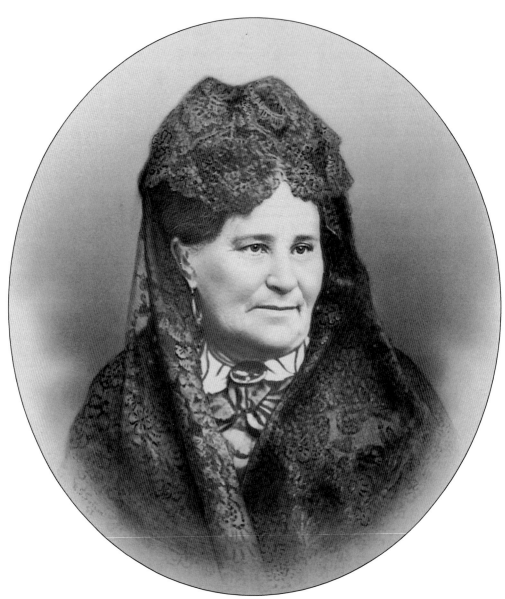

MARIA JOSEFA PETRA DEL CARMEN CARRILLO DE DANA. Prior to the Mexican-American War, there were roughly 200 legal marriages between European/Euro-American men and Mexican women. Many of these women were like Maria Josefa Carrillo, and they came from powerful families and close-knit communities where families utilized kinship and marriage to maintain their status. These women served as the connection between the American businessmen that they married and the Mexican government—two cultures that were sometimes vastly different and required a careful balancing act. This was particularly the case when it came to legal matters. Men like Dana came from the American legal system based that of the British and had to work within Mexican law, which was derived from the Spanish legal system. Women, such as Maria Josefa, had to maneuver and blend aspects of the two cultures most beneficial to themselves and their families in order to survive in the isolated Mexican frontier, which was surely no easy task to complete. This blending, however, resulted in the Californio lifestyle, which has legacies that remain in today's local culture. (Courtesy DANA.)

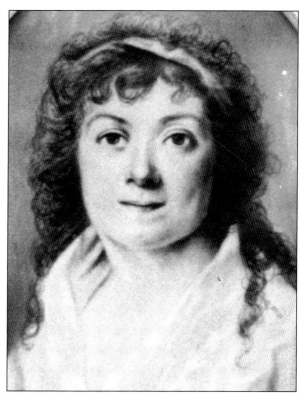

NEW ENGLAND ROOTS. William G. Dana was born into a prominent New England family. Among them were his mother, Elizabeth Davis (right), who lived from 1778 to 1806, and his father, William Dana (below), who lived from 1776 to 1799. The bottom image is somewhat questionable, however. Some are skeptical, as the man in this painting does not appear to resemble the rest of the Dana family. Unfortunately, William G. Dana's parents died when he was young. Dana also had a famous distant cousin, Richard Henry Dana, who wrote the book *Two Years Before the Mast,* and whom Dana Point, California, is named after. (Right, courtesy History Center of SLO County; below, courtesy South County Historical Society.)

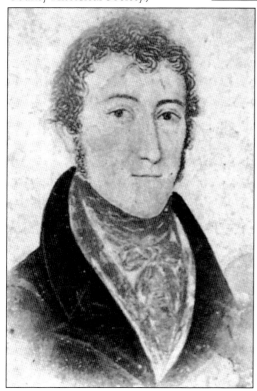

MARIA JOSEFA ANTONIA CERILO DANA. Born on July 9, 1829, Maria Josefa Antonia was the first-born child of William G. and Maria Josefa. She spent most of her early years with the Carrillo family in Santa Barbara. She married one of the first American arrivals to the area, Henry Amos Tefft, in 1849. After his death, she married Samuel Adams Pollard in 1854 and moved to San Luis Obispo. The couple inherited the family's property there. (Courtesy History Center of SLO County.)

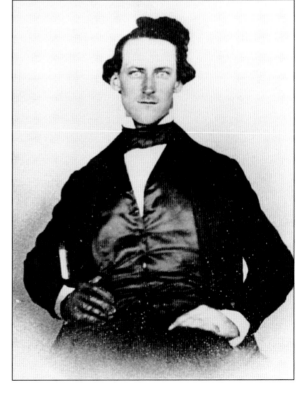

HENRY AMOS TEFFT. Born in Rhode Island, Henry Amost Tefft became a lawyer. At age 25, Tefft was one of the first 10 delegates to participate in the California Constitutional Convention when he immigrated to California. Tefft championed Indian suffrage and women's property rights. However, a storm cut his life short when he was disembarking from a ship in Port San Luis, resulting in his death. (Courtesy History Center of SLO County.)

WILLIAM CHARLES DANA HOME. As the Dana children grew to adulthood, they began moving to different portions of the original Rancho Nipomo Land Grant. William Charles, the first surviving son of William and Josefa, received the Los Berros portion of the rancho. Several photographs of the homes he built exist. Above is one home he may have built, photographed around 1930. It was located along the Pacific Coast Railroad. Below is another home that he built, which still stands today. No known photographs exist of William Charles. (Both, courtesy History Center of SLO County.)

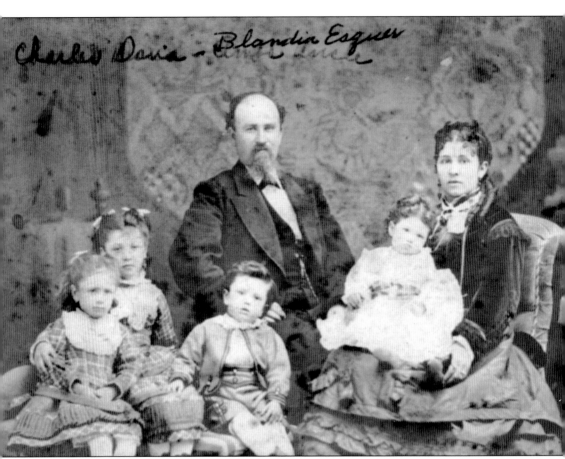

CHARLES WILLIAM DANA. Charles was the second surviving son of William and Maria Josefa, born in 1837. He was educated and held multiple elected offices, including the California State Assembly, the San Luis Obispo County Board of Supervisors, and was mayor of San Luis Obispo. He married Blandina Refugio Esquer in 1866. Here, they are pictured with their children, from left to right, Fidelia (born 1870), Blandina Elena "Nellie" (born 1867), Charles Ernesto (born 1873), and Irene Josephena (born 1874). (Courtesy History Center of SLO County.)

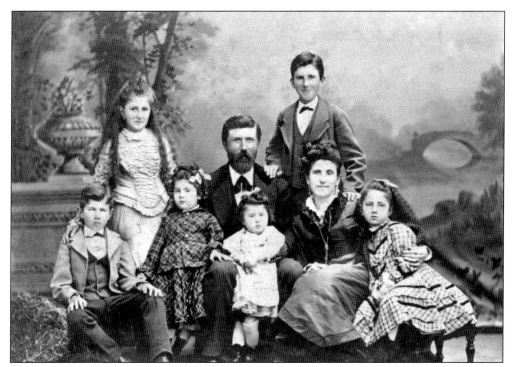

JOHN FRANCIS DANA. John Francis Dana was baptized "Juan Francisco" in 1838. He married Francisca Carolina Thompson y Carrillo on Christmas Eve in 1860 at the de la Guerra home in Santa Barbara. He received 30 acres of Rancho Nipomo as a wedding gift. His family is pictured around 1874, as the children shown, from left to right, are Alexander Albert (born 1866), Josephine Caroline (born 1864), Carolina Engracia "Grace" (born 1871), Elena "Ellen" (born 1873), John Alpheus (born 1852), and Mary "Mollie" (born 1869). (Courtesy the History Center of SLO County.)

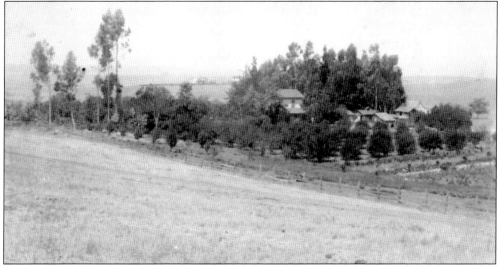

JUAN FRANCISCO HOME. Photographed in 1890, Juan Francisco's home was located near the present Dana Foothill Road. By its side is an orchard and farmland. Unfortunately, the picturesque home was lost to fire, along with the priceless valuables inside. (Courtesy History Center of SLO County.)

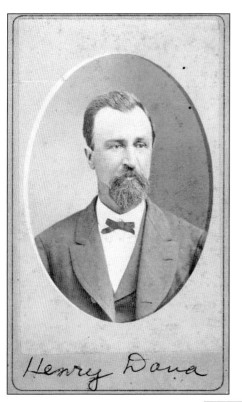

HENRY CAMILO DANA. Henry Camilo was the fourth surviving Dana son and grew up learning ranch management and stock raising. During a raid on the ranch by the infamous bandit Jack Powers, Henry and his brother Ramon managed to sneak out to get help from Don Diego Ontiveras of Rancho Guadalupe (their closest neighbor) during the 1850s. He married Josephine Blake, who was also from Nipomo. The two raised seven children. (Courtesy History Center of SLO County.)

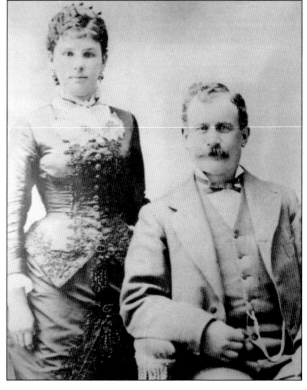

JOSE RAMON IJINIO DANA. Jose Ramon Dana married Elena Francisca Streeter of Santa Barbara in 1873. Prior to that, he worked on the family's cattle ranch and was responsible for driving the cattle to the Bay Area, where he sold them to the famed "Industrial Cowboys" Miller and Lux. After the Dana children partitioned the rancho in 1882, Jose Ramon built his family a home near Price and Carrillo Streets. (Courtesy History Center of SLO County.)

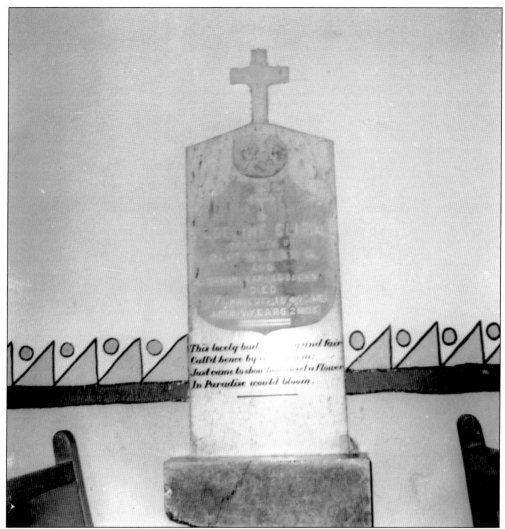

ADELINA DANA'S GRAVE. William G. and Josefa had several children who did not survive to adulthood. One of these children was Adelina Eliza Dana, who was born in 1842 and died in 1847. However, the memory of Adelina will survive in perpetuity as she is entombed in the wall of Mission San Luis Obispo. (Courtesy History Center of SLO County.)

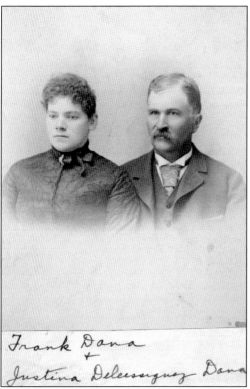

FRANCISCO DANA. As a child, Frank Dana was a shepherd on the family rancho during the 1860s. He married Justina Clara Deleissigues from San Juan Bautista in 1873. They had six children together. The Dana-Deleissigues family built their famous home that still stands today. Frank's son George planted the rose garden and avocado orchard that remain on the property. (Courtesy History Center of SLO County.)

DANA-POWERS HOUSE. One of the iconic structures of the Nipomo area is the Dana-Powers House. It has housed six generations of Danas, beginning with Frank who built the home on his 1,200-acre portion of original Rancho Nipomo. Frank's great-granddaughter Judith and her husband, Edward Chadwell, now live and entertain in the building. Weddings and other events are held at the historical property, continuing the tradition of Dana hospitality. This photograph was taken around 1918. (Courtesy Judith Dana-Powers.)

EDWARD GOODWIN DANA. Born in 1846, Edward was the first Dana child born outside of Santa Barbara. He was the first postmaster of Nipomo and served as the county treasurer from 1877 to 1882. Edward married Virginia Thorp Graves, and the two had eight children, seven of which survived to adulthood. The two had built a house off Paulson Road and south of town, where he ran a dairy. (Courtesy History Center of SLO County.)

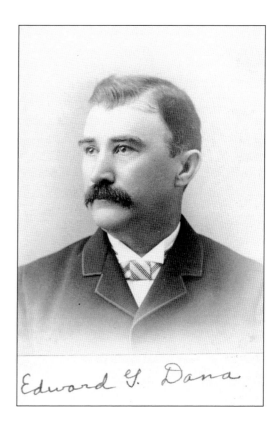

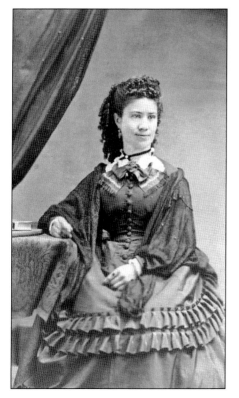

ADELINA ELIZA DANA. The Danas had a second daughter whom they named Adelina. She was the first American-born Dana child as her birth took place a month after the Mexican-American War ended, which officially gave the United States control over California and the West. (Courtesy DANA.)

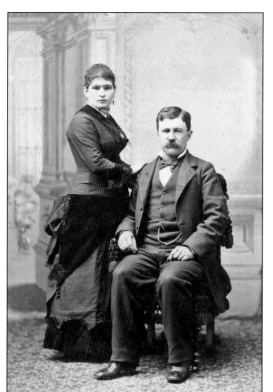

FREDERICK ALBERT DANA. Fred Dana, born in 1849, is listed on most census records as a farmer. He married Manuela Tita Munoz in 1875. When Rancho Nipomo was partitioned, Fred received the portion on which the adobe was located. His family moved into the home and made several renovations, including installing a bathroom. He was elected road master and supervised the construction of roads in Nipomo, Los Berros, and Oso Flaco until he died in a carriage accident in 1899. (Courtesy History Center of SLO County.)

DAVID AMOS DANA. David Dana was only seven years old when his father died, so his mother and siblings raised him. He attended the years of education at the Santa Ynez College and married Cipriana Rojas in 1885. The following year, he built a home near Dana Foothill Road. In 1894, David and his brothers started the Nipomo Creamery Company, located on Thompson Street and between Price Street and Paulson Road. The joint-stock company lasted until 1910. (Courtesy History Center of SLO County.)

ELISHA COLT DANA HOME. No known photographs exist of Elisha Dana. However, he built his home in 1894. Like his brothers, he was educated at the Santa Ynez College. He was also known for his business ethics. One resident wrote, "It was often said that his word was as good as his bond." (Courtesy Santa Maria Times.)

SAMUEL AMBROSE DANA. Samuel Ambrose Dana was the last child born in William Goodwin and Maria Josefa in 1855. He was one of the originators of Nipomo's water works programs to supply the town with water in the late 1880s, and he was the owner of Nipomo Nursery, which supplied trees to customers around Southern California. He also sat on the board of directors for the Bank of Santa Maria, which opened its doors in 1890, and the Commercial Bank of San Luis Obispo. (Courtesy History Center of SLO County.)

S.A. Dana Home. Samuel Ambrose Dana had several, large real estate holdings in the area, among which was his section of the original Rancho Nipomo. He was the last of the Dana children to build a home as the architecture of his Craftsman Bungalow–style residence demonstrates. Initially, he was single and providing a home for his widowed niece Mollie Krider and her children. However, he married Maria Antonio Alviso in 1903. (Courtesy Santa Maria Times.)

Grocery List from the 19th Century. In 1852, William G. Dana placed an order of supplies. All of these supplies came from distant cities, and would be delivered by ship in Port Hartford. Among his requested list are a Guernsey frock, brandy, whiskey, and wine. Lists such as this provide insight into the goods the Dana family needed to survive in 19th-century California. (Courtesy History Center of SLO County.)

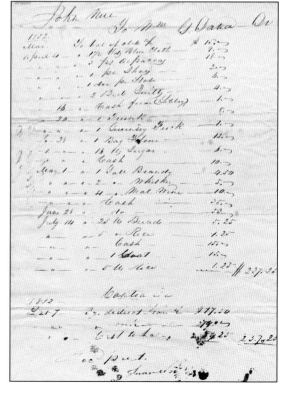

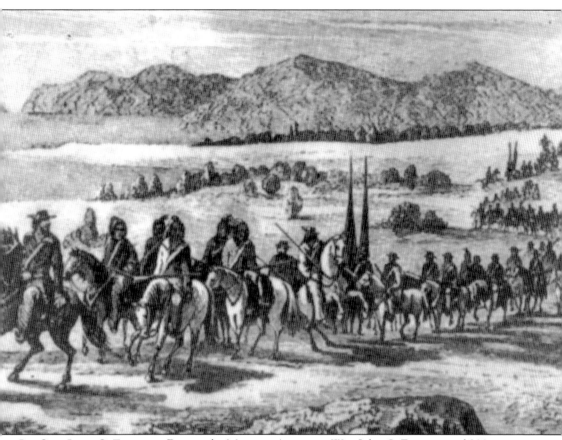

LT. COL. JOHN C. FRÉMONT. During the Mexican-American War, John C. Frémont and 300 men traveled down the coast of California, stopping in Nipomo overnight. The men camped in an area referred to as "Summit," possibly being the Summit Station area today. William G. Dana provided the men with supplies, including 40 head of cattle. Frémont's expedition continued to Santa Barbara, where they captured the Presidio in 1846. This led to the United States annexation of California. Frémont served as military governor of California for a short time, as well as a few months as one of the state's first senators. He also led two failed presidential attempts and became a major general during the Civil War. Many argue that the Mexican-American War provided training for men, such as Frémont, that served in the Civil War. (Courtesy South County Historical Society.)

PALE YELLOW-LAYIA. One of the first American guests that the Dana family hosted was Charles Christopher Parry in 1850. Parry was the first American botanist to survey the lands newly acquired by the United States from Mexico. He collected a specimen of the Pale-Yellow Layia (*layia heterotricha*) from the Dana rancho. Unfortunately, the flower is now on the endangered species list as it only occurs in particular areas of nine Central California Counties. (Courtesy Christopher Christie.)

HUTTON'S VIREO. William Rich Hutton was a surveyor for the American government, as well as a friend of William G. Dana. He was a guest at Rancho Nipomo and served as the county surveyor until 1851. While traveling, he identified a type of bird that would become Hutton's Vireo (*vireo huttoni*). (Courtesy Minette Layne.)

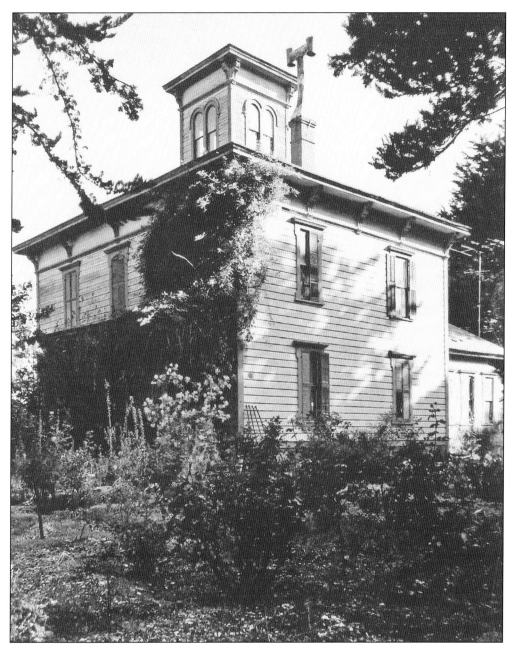

JOSEFA DANA'S HOME. After the passing of William G. Dana, Maria Josefa's family built her a home closer to town. Stories maintain that the Dana family only agreed to give the Pacific Coast Railway a right-of-way through their property if the company allowed Maria Josefa to ride free for life. Maria Josefa enjoyed the cupola on top of the home so she could see all of her children's homes around the Nipomo Valley. The author Myron Angel noted the house when he wrote, "For the venerable and venerated mother an elegant home of modern architecture has been constructed, which is a conspicuous object as the traveler passes in the rapidly flying train." (Courtesy South County Historical Society.)

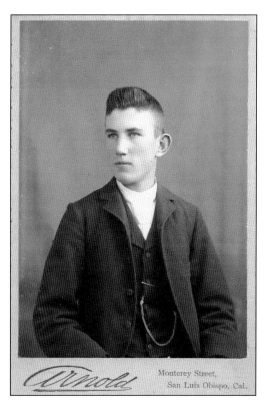

Monterey Street,
San Luis Obispo, Cal.

EDWARD DANA. Juan Francisco's son poses for the camera in his high-end clothing and pocket watch from around 1890. An unknown author wrote a message on the back of the photograph stating, "Edward Dana—The brute of the family. Aged sweet sixteen. May he live and flourish forever and then go to grass with the rest of the cattle." (Courtesy History Center of SLO County.)

VIRGINIA GRAVES. Virginia Graves (wife of Edward G. Dana) demonstrates local 19th-century fashion. Looking at clothing choices provides insight into shopping habits, economic status, changing access to goods, individual style, fashion trends, and technological advances. The arrival of the railroad in 1882 not only provided for easier travel but also connected locals to the urban areas in the United States. The railroad made it easier to participate in national trends and order clothing made by professionals in outside areas. Also, note that, while black now is associated with mourning, high-end and 19th-century clothing was often black because it allowed for dirt and dust, which was abundant everywhere, to be less obvious. (Courtesy History Center of SLO County.)

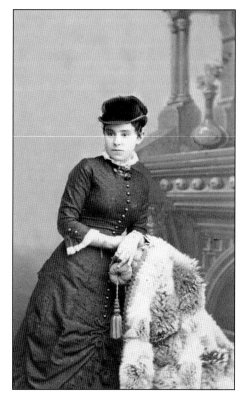

DANA MONUMENT. The cemetery in San Luis Obispo contains the monument demarking the site of William G. Dana and Maria Josefa. William G. Dana died on February 12, 1858. Maria Josefa survived him until September 25, 1883. It stands as a marker for all of the contributions that the Dana-Carrillo union made to the local area. (Courtesy History Center of SLO County.)

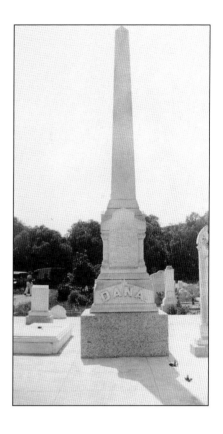

ALONZO DANA, C. 1913. Alonzo Patrick Dana poses for his portrait. Alonzo spearheaded the movement to preserve and restore some of the historical buildings in Nipomo. (Courtesy South County Historical Society.)

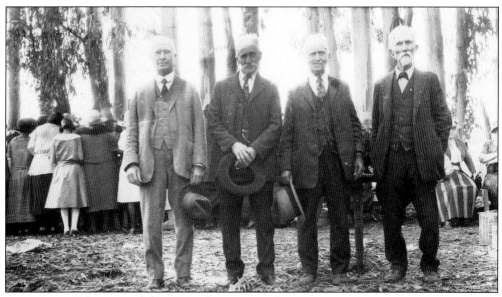

DANA SONS. Taken around the 1920s, the surviving first generation Dana sons pose together for a photograph. From left to right are Frank, David, Edward, and Juan Dana. (Courtesy History Center of SLO County.)

THE TWO JOHNS. Juan Francisco Dana and John Alpheus Dana stand together. John Dana is wearing a 1920s-era Army uniform. (Courtesy History Center of SLO County.)

Juan Francisco Dana. At age 93, Juan Francisco stands in the doorway of what remained of the old blacksmith shop near the Dana Adobe in 1931. (Courtesy History Center of SLO County.)

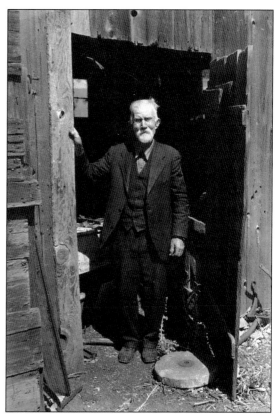

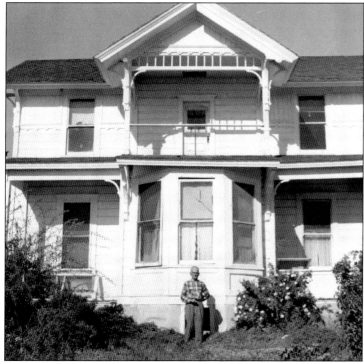

David Dana Jr. Taken around 1960, this picture shows David Dana Jr. (born 1888) standing in front of his home in Nipomo. David Dana's home was located near Dana Foothill Road. (Courtesy History Center of SLO County.)

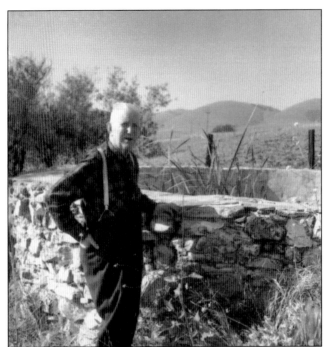

EDWARD ELISHA DANA. Born in 1875, this photograph shows one of Jan Francisco Dana's sons, Edward (age 85), next to a reservoir he helped his father build. It is unknown whether there are still remnants standing today. (Courtesy History Center of SLO County.)

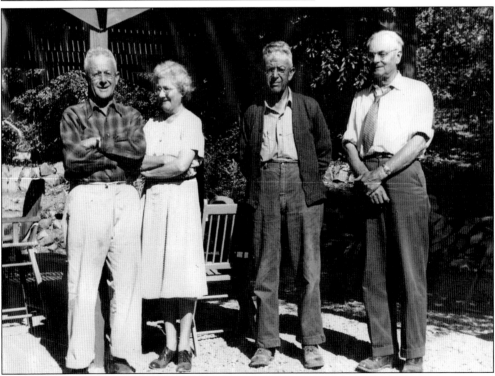

THIRD GENERATION DANAS. Four of Jose Ramon's children were photographed together around 1950. From left to right are Arthur Dana, Alma Dana Deleississigues, Leslie Dana, and Chauncey "Chance." This photograph was taken at the home of Leslie and Clara Dana in San Luis Obispo. (Courtesy History Center of SLO County.)

GERARD, GEORGE, AND ALONZO. From left to right, Judge Gerard S. Dana, George O. Dana, and Alonzo P. Dana stand in front of Frank Dana's 19th-century home, known today as the Dana-Powers House. George was Frank Dana's son. Alonzo Dana helped initiate the Dana Adobe preservation movement and greatly contributed to the San Luis Obispo County Historical Society—now the History Center of San Luis Obispo County. (Courtesy Santa Maria Times.)

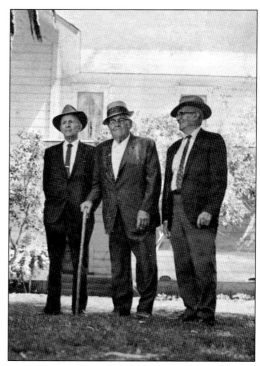

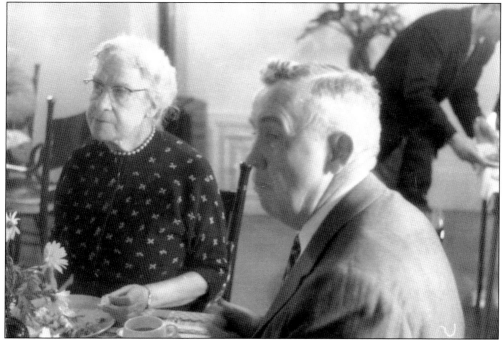

DAN SHEEHY. Dan Sheehy joined the Dana family when he married Lizzie Dana, William G. Dana's granddaughter. Sheehy Road in Nipomo was presumably named after his family. Dan Sheehy is next to Anita Hathway, president of the San Luis Obispo County Historical Society, during a luncheon the organization held for the board of supervisors on February 11, 1958. (Courtesy History Center of SLO County.)

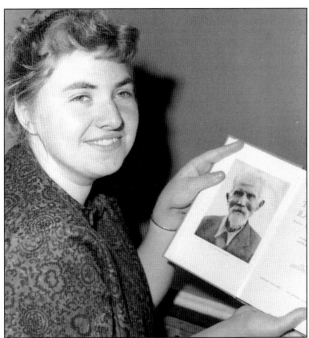

BOOK RELEASE. The year 1960 saw the release of Juan Francisco's oral history in book form. Pictured here is an unidentified reader viewing the book upon its debut that year. It was entitled *The Blond Ranchero* and described life on Rancho Nipomo, including an account by Juan Francisco about his experience sitting on General Frémont's shoulders during the US military conquest of California. Much of the available information on the Dana family comes from Juan Francisco's memoirs. (Courtesy History Center of SLO County.)

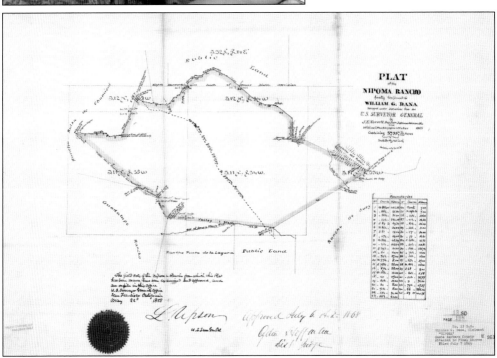

PLAT OF THE RANCHO NIPOMO. Due to the number of land grants the US court system had to process and the interest by American land speculators that wanted to see the large Mexican land grants subdivided, land grant confirmations were often tied up in court system for many years. The Danas finally had their land grant confirmed by the US District Court in 1868, which was 18 years after the federal government grated California statehood and 10 years after William G. Dana passed away. (Courtesy Bancroft Library, University of California, Berkeley.)

Two

CREATING A COMMUNITY

Since the town's beginning, Nipomo has always been an agricultural community. The Dana family's initial focus was cattle—first for hides and tallow to ship worldwide and then to supply the forty-niners in Northern California with meat during the Gold Rush. After the Gold Rush ended, the price of meat crashed while severe drought caused the death of thousands of cattle. During this time, the Danas turned to sheep. Northern industrialists needed wool during the Civil War to fill the void left by the succession of the Southern cotton-producing states. The arrival of the Pacific Coast Railroad would kick off more change in agriculture in the form of varying crops residents were growing, as well as the development of the town of Nipomo.

In 1882, the Pacific Coast Railroad began offering service from Port Hartford (now Avila Beach) to San Luis Obispo and continued to the Santa Ynez Valley. The railroad stopped in towns along the way, of which Nipomo was one of them. With the introduction of the railroad, property values increased, and farmers gained speedy access to markets around the world via ship. Wheat was the initial crop of choice, as it was a staple of the American diet. Excellent soil and climate, in combination with relatively rapid transportation, allowed farmers to grow specialty crops, such as beans and peas, and sell to distant markets. Farmers could ship crops to markets without spoiling, which was thanks, in part, to the railroad.

Agriculture not only altered the physical environment in the form of changing crops and irrigation systems but also altered the community's ethnic makeup. The specialty crops farmers grew required workers willing to do physical labor. Initially workers came as individuals, mostly from around Europe, as well as Chinese immigrants that found themselves on the Central Coast due to the railroad. However, as crop output grew exponentially, a more organized system developed in which farmers hired labor contractors to recruit laborers. By 1910, much of Nipomo consisted of Japanese migrant farm workers, many of which planted the groves of eucalyptus trees that are still on the Mesa today. The 1920s saw an influx of Filipino workers as the federal government essentially banned immigration from abroad. Labor contractors began recruiting laborers from the Philippines, a US possession acquired during the Spanish-American War in 1898, and therefore Filipino workers were not subject to the anti-immigration laws.

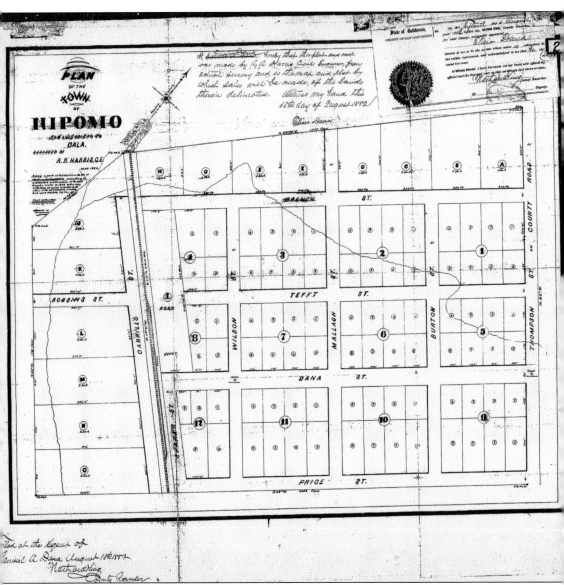

PLAN OF THE TOWN OF NIPOMO. The first plan for the subdivision of Rancho Nipomo came in 1882. The streets were named after friends and family members of the Dana family. Tefft Street was named after William and Maria Josefa's first son-in-law. Robbins, Burton, Mallagh, Thompson, and Wilson were all men that married into the Carrillo family and received Mexican land grants. Price and Sparks, both of the Pismo Land Grant, worked for Dana at various times, while Branch was the Danas neighbor to the north. Dana Street was originally intended to be the main thoroughfare through town. The subdivision appears to have been a joint venture between the Dana children as Samuel A. Dana filed the request and Elisha Dana signed the final paperwork. (Courtesy San Luis Obispo County.)

SAMUEL A. DANA SUBDIVISION.
Each of the Dana children received a portion of the land grant upon its dissolution. Some of them almost immediately subdivided to take advantage of increased property value due to the arrival of the railroad. This 1887 map shows how Samuel A. Dana subdivided his portion of land north of Tefft Street, where many people still live today. (Courtesy San Luis Obispo County.)

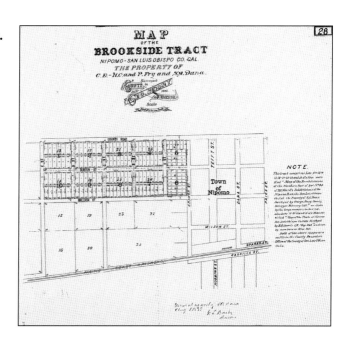

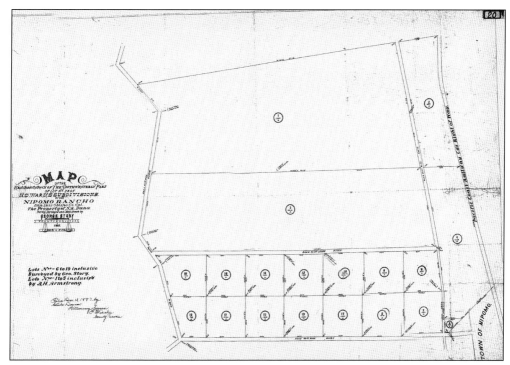

ELISHA DANA SUBDIVISION. Elisha Dana also subdivided his property in 1887. This property subdivision appears to be framed by the current roads of Oakglen on the east, Tefft on the south, and Pomeroy on the west. (Courtesy San Luis Obispo County.)

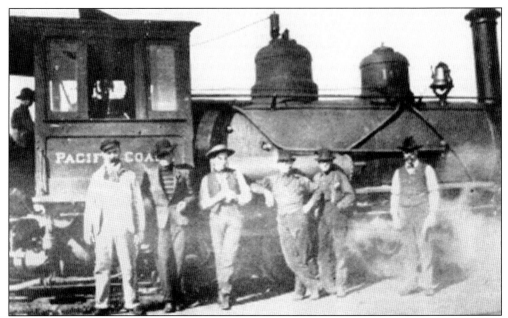

PACIFIC COAST RAILROAD. The locomotive for the Pacific Coast Railroad stops in Nipomo while six unidentified men pose. It was one of the stops along the Pacific Coast Railroad, which also included stops in San Luis Obispo, Arroyo Grande, Santa Maria, and Los Alamos. The railroad turned Nipomo into a boomtown, which by 1887 had two hotels, a general store, a blacksmith shop, a schoolhouse, a hardware store, a feed stable, real estate offices, three saloons, and even a newspaper titled the *Nipomo News*. (Courtesy DANA.)

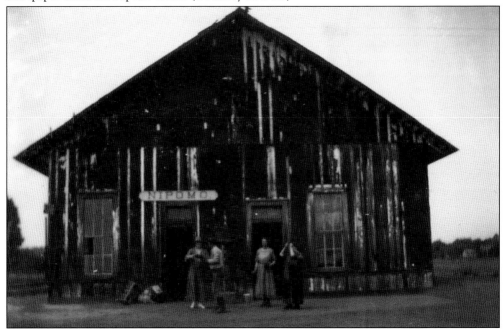

RAILROAD DEPOT. Four people stand in front of the Nipomo Railroad Depot around 1910. The railroad allowed farmers to ship out their product and people to travel more quickly than they could have before with a horse and buggy. (Courtesy History Center of SLO County.)

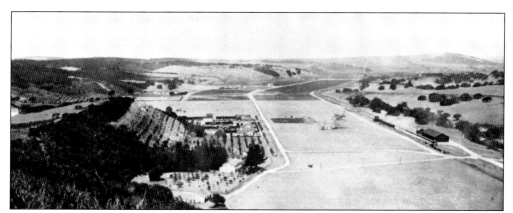

LOS BERROS. The Pacific Coast Railroad (PCR) also led to the subdivision of William Charles Dana's property. This panorama shows the PCR bisecting the valley. In the foreground is William Charles Dana's house. (Courtesy History Center of SLO County.)

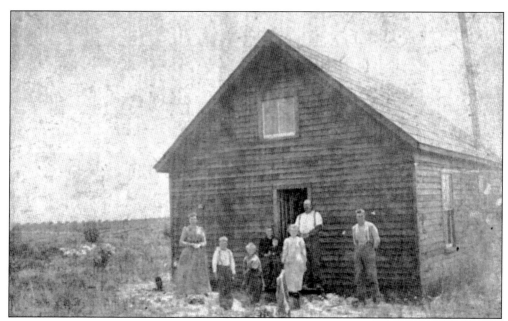

THE BRISTOL HOME. Pictured here is the Bristol family standing in front of their home in 1884. It was one of the first homes given the establishment of the town in 1882. From left to right are Jennie, Bert, Carrie, Glen, Sarah holding Chester, Edna, Charles, and Joe Bristol. In front of the home appears to be a pole so visitors could tie up their horse. (Courtesy Marge Baker.)

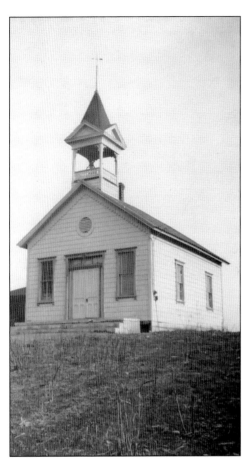

NIPOMO'S FIRST SCHOOLHOUSE. Nipomo's first one-room schoolhouse, built in 1887, is still located on Dana Street. The Dana family reportedly donated it to the community. Various Protestant denominations used the building as a church until it was organized as the Nipomo Community Presbyterian Church in 1948. They built additions on to the building as membership grew, using an old building moved from Guadalupe. The Presbyterian church was located in this location until it moved in 1992. (Courtesy Nipomo Community Presbyterian Church.)

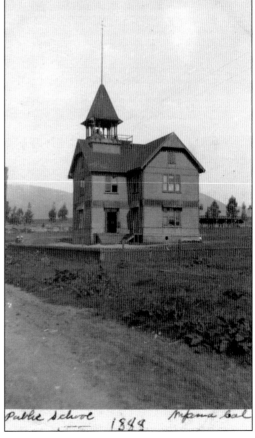

NIPOMO GRAMMAR SCHOOL. The 1880s saw a larger school built for the town, as this postcard from 1888 demonstrates. Nipomo was such a boomtown that the original school was overcrowded the first year it was utilized. Residents decided to built a new, larger school at the current site of Nipomo School. The new school had two stories and contained a bell tower, and the school board sold the original school to the Methodist Church for $1,025. (Courtesy History Center of SLO County.)

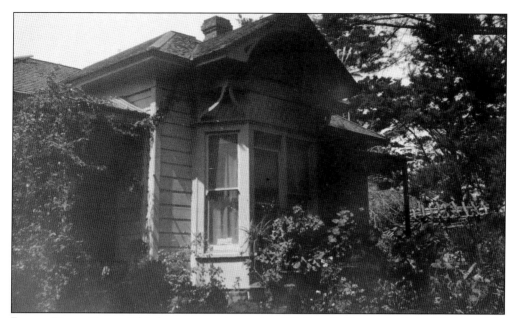

ROCKY DANA HOME. This home, once located at 271 East Tefft, was built in 1887 by a Mr. Schwartz. Rocky Dana purchased the home later, and it developed a reputation for its "interesting" yard by the 1960s. Also of interesting note, most of the Victorian era structures around Nipomo are fairly informal, while this home had more ornate decoration. (Courtesy History Center of SLO County.)

THE KNOTTS. Pictured here are Emory and Lenora Knotts around 1875, the founders of one of Nipomo's first saloons. They came from Ohio and Indiana, respectively. Over the years, each of the Knotts's seven sons and four son-in-laws helped run the saloon, including Ralph "Jocko" Knotts, for whom Jocko's Restaurant is the namesake. Emory Knotts founded an enterprise that may be one of the most renowned institutions in Nipomo today. (Courtesy Jerry Knotts.)

SARAH MCNEIL BRISTOL. Sarah McNeil was born in Massachusetts in 1855 and eventually found herself in Missouri where she married her Civil War–veteran husband, Charles Bristol. Eventually the two moved to Nipomo. (Courtesy Marge Baker.)

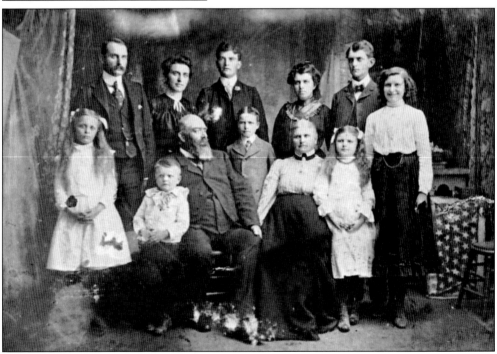

THE BRISTOL FAMILY. Charles and Sarah Bristol arrived in Nipomo by train, where they later had 13 children, 10 of which survived beyond infancy. Here, the family is posed around 1903. They are, from left to right, (first row) Charlote, Elbie, Charles, Chester, Sarah, Cora, and Caroline; (second row) Joe, Jennie, Bert, Edna, and Glen. (Courtesy Marge Baker.)

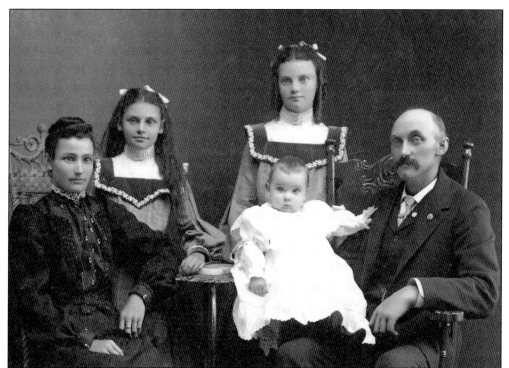

THE MEHLSCHAU FAMILY. One of the successful immigrant families in Nipomo was the Mehlschaus from Germany. Hans Mehlschau immigrated to the United States during the 1880s according to the 1900 census. Pictured in this 1905 photograph are the Mehlschaus and their children, who are, from left to right, Flora, Mattie, and Hans Jr. Mehlschau Road is named after the family. (Courtesy History Center of SLO County.)

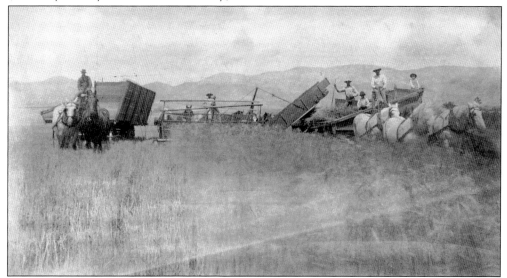

HARVESTING, 1902. The Mehlschau harvesting crew is using a threshing machine to separate grain from stalks and husks in order to harvest wheat. The photograph indicates that Bert Johns was driving a "fast team." Hans Mehlschau is on the header, while Andrew Mehlschau is driving the team of white horses. The others are unidentified. (Courtesy History Center of SLO County.)

CALLENDER STATION. C.R. Callender, a Los Angeles businessman, participated in the area's land speculation when he purchased large portions of the Nipomo Mesa. He began planting eucalyptus trees, which was encouraged by the state to meet growing lumber demands. Callender also built a rail line to the area for the transportation of people and wood. During the late 1890s, Callender sold the land to a Mr. Pomeroy, who subsequently sold the land to Pasadena businessmen that started the Los Berros Forest Company. The majority of the trees planted (85 percent) were Tasmanian Blue Gums, which, as many residents know today, are messy, prolific, invasive, and not particularly suitable for wood products. The eucalyptus industry collapsed, leaving abandoned forests where they still stand today. (Courtesy South County Historical Society.)

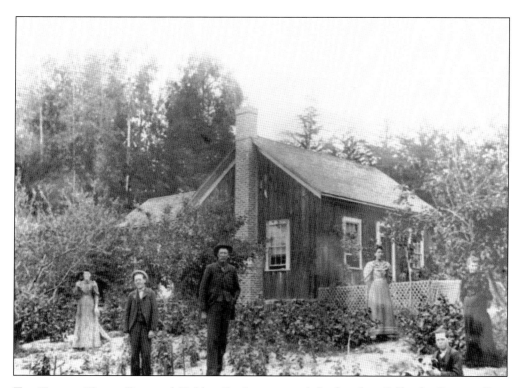

THE FOWLER HOME. Burt and Goldyn Fowler managed the hotel at Callender Station. Burt would pick up the Los Angeles businessmen that owned the area from the railroad station when they came to town. Goldyn would cook their meals. Above is the outside of the Fowler residence with unidentified family members standing around the home, and below is their living room. The Fowlers were given the home and paid $75 a month as caretakers. (Both, courtesy South County Historical Society.)

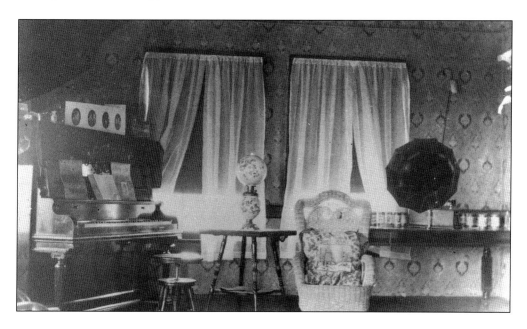

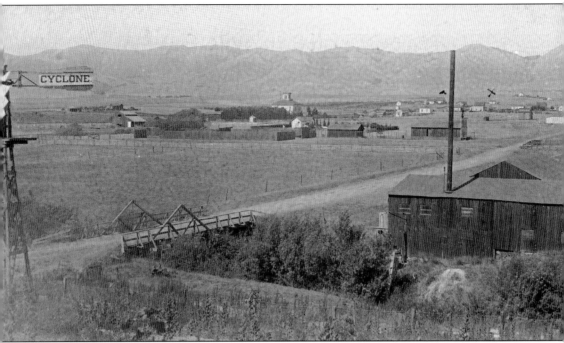

NIPOMO IN 1890, PART ONE. This photograph shows Nipomo in its entirety in 1890. Looking east towards the hills from the edge of the Mesa, the dirt road in the foreground is possibly Branch Street, as Tefft ended at the train station according to county maps. Also visible in the middle of the photograph is Maria Josefa's house, the tallest building in Nipomo at the time. Nipomo School is also visible in the distance. The back of the photograph states that the stacks of bags

NIPOMO IN 1890, PART TWO. This is another view of Old Town Nipomo, looking south down Thompson Street. Visible again is Nipomo School, and the buildings that are today known as the Kaleidoscope Inn and Rosie's Restaurant. A fence in the foreground points out that it was the road to Arroyo Grande. In 1899, the *Los Angeles Times* declared "San Luis Obispo County snowed

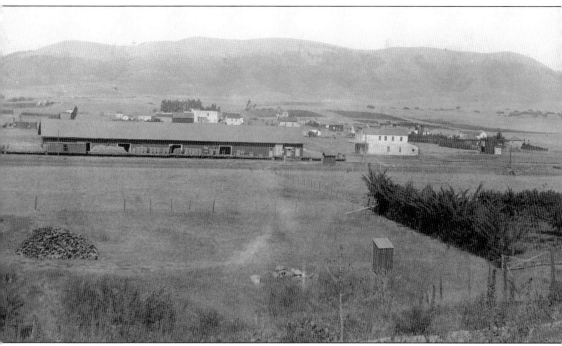

at the railroad station contained beans that were awaiting removal by the train. The photograph also states which houses were marked on the photographs. "Mr. Morgan's house marked in with cross. Mr. Bell's with a straight mark. Our home with a half diamond." Also marked on the hill is "deer," possibly demarking the location of a hunting cabin that William G. Dana is said to have had. (Courtesy History Center of SLO County.)

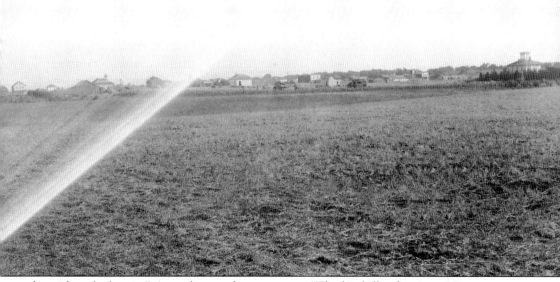

under with sacked grain." According to the newspaper, "The big hills of grain at Nipomo are growing larger." Looking southwest from Thompson Street, the freshly threshed fields are visible, as well as Mrs. Dana's house on the far right. (Courtesy History Center of SLO County.)

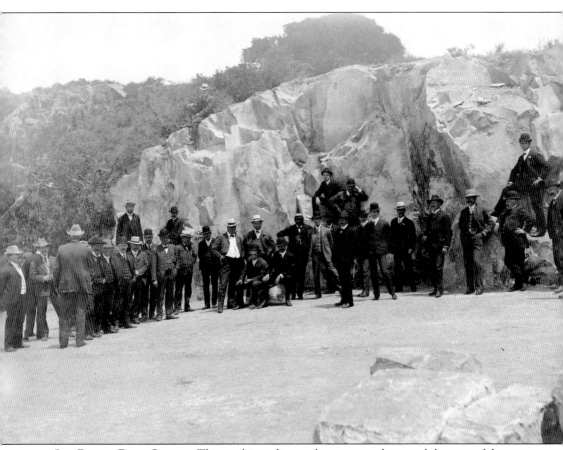

LOS BERROS ROCK QUARRY. The outskirts of town also saw growth around the turn of the century. On May 4, 1904 a rock quarry opened in Los Berros, for which many Los Angeles investors made the journey. The quarries produced volcanic tuff, a form of rock that is soft and porous and was often used to create building facades during the period. Rock from the quarries located around Los Berros were loaded onto the Pacific Coast Railroad, and used for building material in the local area. It was also shipped to Los Angeles via Port Hartford. The arches and window detailing on the History Center of SLO County were reportedly created using stone from Los Berros when the Carnegie Library was constructed. (Courtesy History Center of SLO County.)

Los Berros Schoolhouse.
Los Berros, originally planned
to be its own community,
also had a one-room
schoolhouse. This picture
is dated 1964, but the date
on the abandoned building
shows that it was built in 1891.
Also visible are a flagpole
and a goat. (Courtesy History
Center of SLO County.)

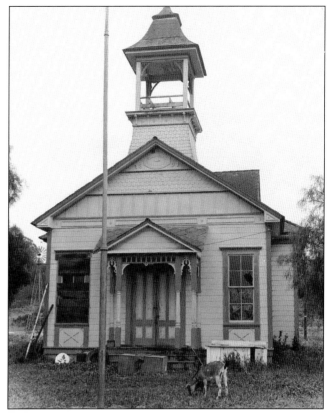

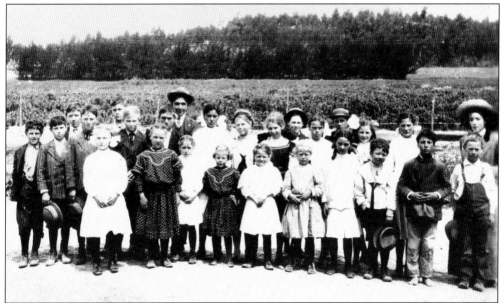

Los Berros School Class. William and John Dana, being some of the first residents in the northern portions of Nipomo, had children that attended the Los Berros School. William Dana also served as one of the school's first trustees. Pictured here is the school's 1914 class. (Courtesy History Center of SLO County.)

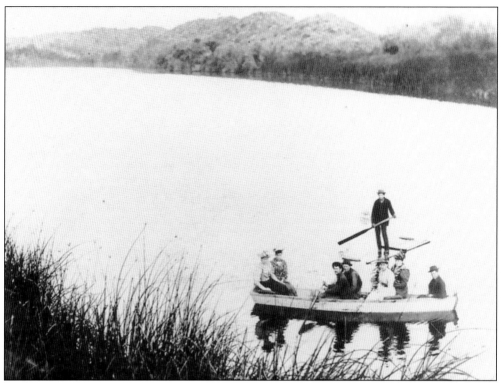

BLACK LAKE. In 1895, a boat of unidentified people and a man on a raft pose for a photograph on Black Lake. This was prior to the planting of eucalyptus trees. (Courtesy South County Historical Society.)

V.S. RUNELS HOUSE. Vitalis Runels commenced construction of his home on Dana Street in 1887. Cost was estimated at $6,000 for the floor plan that showed four rooms, a large paneled hall, a second story, and an attic, all furnished with modern conveniences. The family sold the home to Joseph A. Dana who ran the mercantile store in town for 35 years. The home was site to social affairs and pleasurable activities. Local resident Patricia Zornes created this sketch of the house in 1947. (Courtesy Hal Baker and Maria Zornes Baker.)

The Winemans. In 1866, Edward and Catherine Wineman immigrated to the United States from Germany. They were successful enough to purchase a large tract of Rancho Nipomo and enter into the ranching industry. The couple also became prominent citizens and played a major role in the development of Nipomo, including the building of St. Joseph Catholic Church. (Both, courtesy South County Historical Society.)

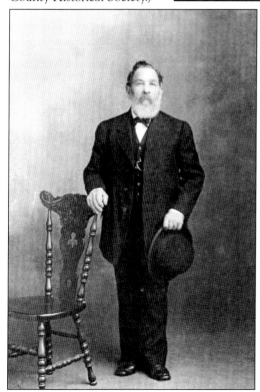

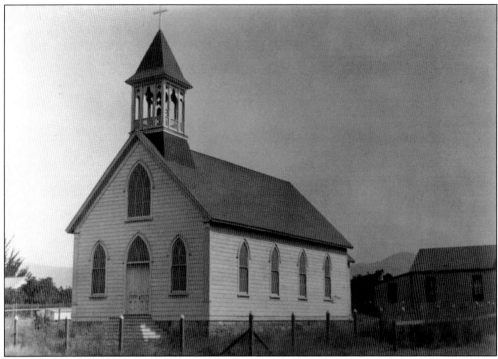

ST. JOSEPH CATHOLIC CHURCH. From 1898 to 1903, Catherine Wineman supervised the construction of Nipomo's Catholic Church. Rock for the foundation was quarried from the Wineman property, while Catherine was responsible for most of the fundraising required to build the church. The majority of funds were donated by Dana family members, and their names are inscribed in the church's stained-glass window that was also donated by the Wineman family. (Courtesy History Center of SLO County.)

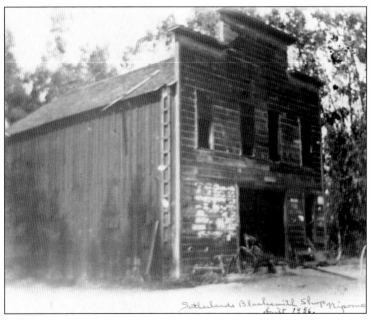

SUTHERLAND'S BLACKSMITH SHOP. This blacksmith shop was reportedly located on Dana Street. The Sutherlands advertised in the local paper, the *Nipomo News*. They specialized in carriage and woodwork "with special attention to fine horse shoeing." (Courtesy History Center of SLO County.)

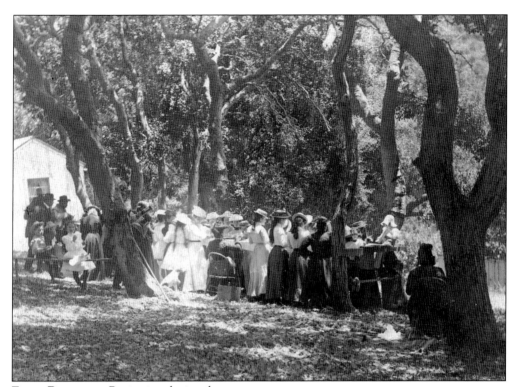

EARLY BARBECUE. Beginning during the late 1800s, Nipomo residents began holding community barbecues. This tradition continued until the 1960s. Pictured here in the Los Berros area are women wearing formal clothes and preparing a meal, while the men are standing to the left holding bottles and the children watch. (Courtesy Jerry Knotts.)

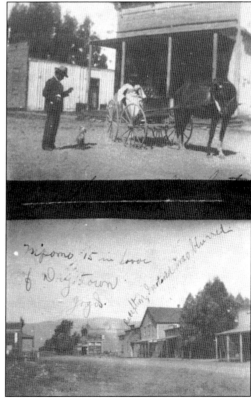

POSTCARD. In 1906, a Mrs. Albert Deleissigues of Los Angeles received a postcard from Nipomo, but the sender is unknown. The top photograph of the postcard is labeled "Mama, Papa, and Ponchita." Ponchita was apparently the family dog. The bottom photograph shows Dana Street from the period. It also states, "Nipomo—15 in favor of Dry town," apparently signifying there was a ballot measure to ban alcohol in the town. (Courtesy Jerry Knotts.)

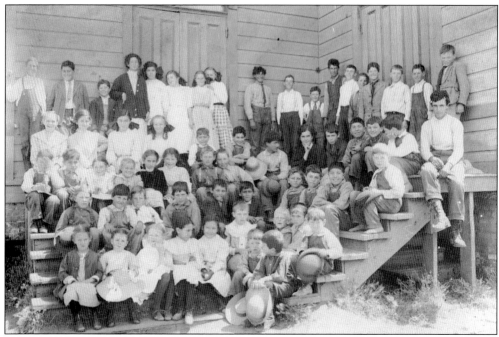

CLASS PICTURES. These Nipomo School class pictures are from around 1910. The class was small enough to fit into a single picture. The 1910 census lists Maria Dana, Bessie Swartz, Leslie Grigsby, Margaret Moore, and Lenora Boomhaven as teachers, so they may possibly be the adults in the photographs. The class pictures also give the opportunity for a closer examination of the old schoolhouse. (Both, courtesy Jerry Knotts.)

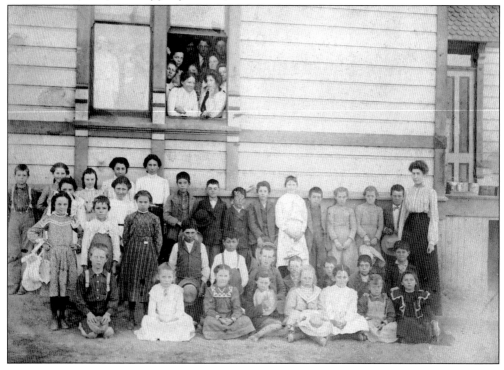

CHESTER AND ELBIE BRISTOL. Posing here, from left to right, are Chester and Elbie Bristol. In 1909, the two were crossing an empty field when a bull began chasing them. Chester saved his younger brother by pushing him up a tree but at his own detriment. (Courtesy Marge Baker.)

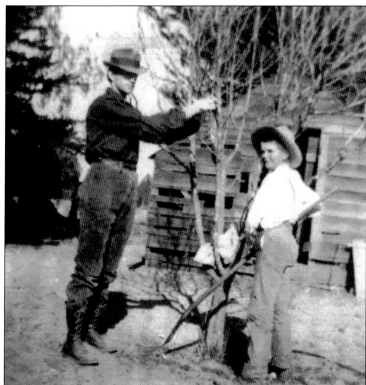

GLEN AND ELBIE BRISTOL. Agriculture was an integral part of most Nipomo residents' lives in the early days. Here, Glen and Elbie get ready to maintain a fruit tree growing in their yard in this c. 1910 photograph. (Courtesy Marge Baker.)

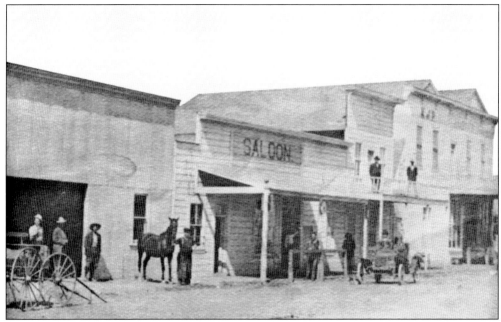

ONE HORSE TOWN. This image was captured at a unique point in history in which horses and cars shared the road. These buildings were located on Thompson Street at Tefft Street. The building on the left was constructed in 1908 as a garage and would have serviced the area's first cars and farm machinery. It still stands today, vacant and painted red. An empty lot sits where the three buildings on the right used to stand. (Courtesy Nipomo Chamber of Commerce.)

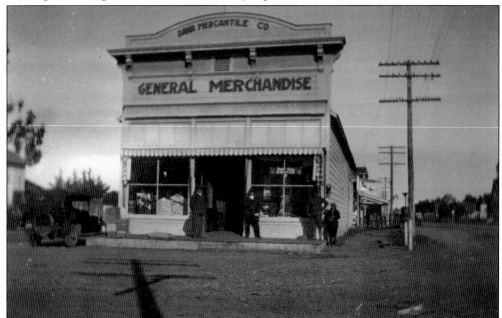

DANA MERCANTILE COMPANY. Nipomo's general store is still standing today on the corner of Thompson and Dana Streets without the facade. It is pictured here around 1910. Later, people referred to the location as the Lucas Store, which served as a social gathering spot for community members. (Courtesy History Center of SLO County.)

DANA HALL. The region contained many saloons and gathering places for local residents to congregate. Among them was Dana Hall, located across the street from the Dana Mercantile Company on Dana Street. (Courtesy History Center of San Luis Obispo County.)

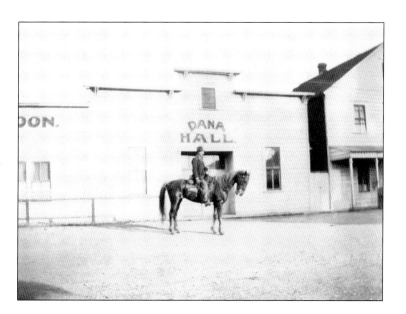

NIPOMO POST OFFICE, C. 1910. Nipomo's post office was located in the back portion of the Dana Mercantile Company. Also partially visible on the right is the old barbershop that still stands today. Across Thompson Street stands a flag at half-mast for an unknown reason. Today, the flagpole is reportedly located at St. Patrick's Catholic School in Arroyo Grande. (Courtesy History Center of SLO County.)

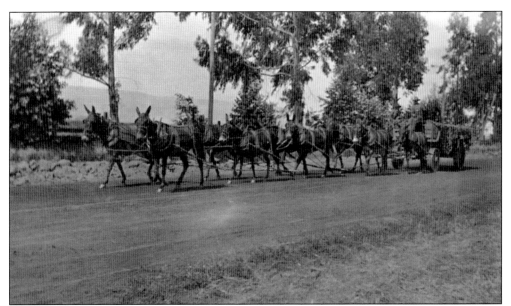

BETTERAVIA TEAM. Teams of horses and mules once transported people and supplies around the Central Coast, which required traveling through Nipomo. Pictured here is a team carrying sugar produced at the Betteravia Sugar Plant. Many of the workers in the sugar-beet industry were Asian immigrants, which caused a stir around the turn of the century. (Courtesy DANA.)

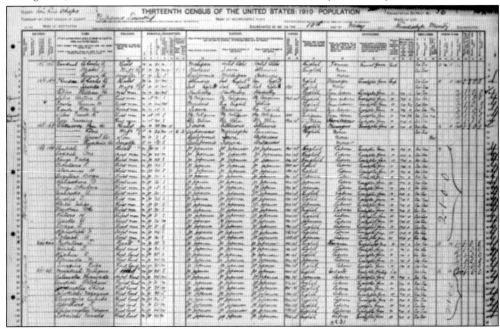

US CENSUS, 1910. The 1910 census shows the prevalence of the Japanese community in Nipomo. They planted the vast acres of eucalyptus trees that are visible around Nipomo today. Most had their occupation listed as "laborer." However, many Japanese residents had occupations listed as "foremen" and "contractor," demonstrating the evolution of the labor system that would be used later, particularly during the Great Depression. It also appears that this particular community lived together on what the census taker listed as Nipomo Mesa Road. (Courtesy US Census Bureau.)

ACROSS THOMPSON STREET STOOD A FLAGPOLE. In the period prior to World War I, troops traveling through town stopped at the flagpole on their way south. A sign near the flagpole pointed to the direction of cities that were north and south, as Thompson Street served as the major highway through town at the time. (Courtesy Jerry Knotts.)

NIPOMO'S FIRST TELEPHONE. According to this photograph, Nipomo's first telephone was located in John Cook's general merchandise store. It sat on the southeast corner of Dana Street and Highway 101, which is now Thompson Street. Looking east down Dana Street, the John Cook store is located on the right. This view is similar to the 1906 postcard but with utility lines added. (Courtesy Jerry Knotts.)

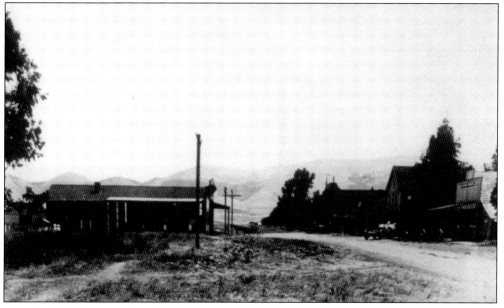

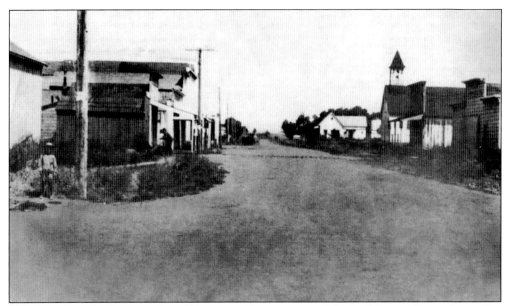

NIPOMO, 1913. Looking north on Thompson Street, many of the buildings still standing today are visible. On the left is the barbershop and the red building that stands empty today. On the right are Rosie's Restaurant, St. Joseph Church, and the feed store. (Courtesy DANA.)

J.A. DANA HOME. Minnette Dana (left) and her friend Laura Lee (right) pose in front of Joseph Armand Dana's home pictured around 1915. Joseph Dana purchased the home from Vitalis Runels, who built the structure in 1887 out of imported redwood. The house remained in the Dana family until the 1960s. Today, the home is known as the Kaleidoscope Inn and serves as a bed and breakfast. (Courtesy South County Historical Society.)

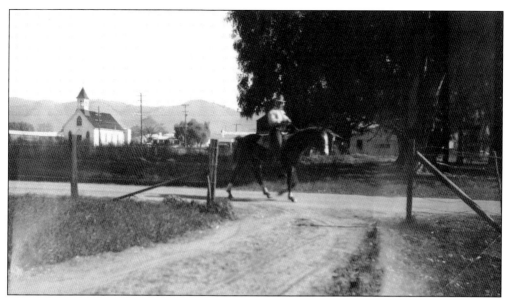

MOUNTED MAN. A sight not seen today is a man on horseback in Old Town Nipomo. He is riding south down what appears to be a path in between Burton and Thompson Streets. In the background are St. Joseph Catholic Church and the red garage, both of which still stand today, as well as a two-story building that is no longer in existence. (Courtesy Jerry Knotts.)

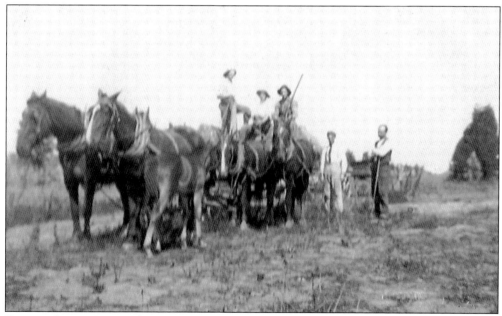

DIGGING SPUDS. Among the variety of agricultural goods that began to appear in the region were potatoes. On the horse-drawn cart are men only identified as Clayton, Ency, and Bryon. The three men had a contract to grow potatoes. The two men on the right are unidentified. (Courtesy South County Historical Society.)

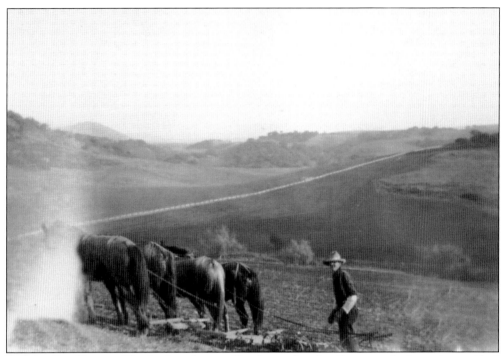

FARMING LOS BERROS. The fertile soil created by the creek in Los Berros made the region an ideal place to farm. Leonard Fernamburg plows the soil with his four-horse team in this photograph. (Courtesy South County Historical Society.)

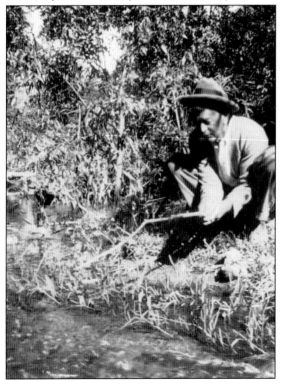

FISHING NIPOMO CREEK. Bert Adams is fishing in Nipomo Creek in this c. 1920 photograph. Adams was Jocko Knotts's brother-in-law. At one time fish were abundant in the creek. Work is currently underway to restore the watershed area to make it habitable for fish once again after years of water supply and quality issues, habitat destruction, and blockages of fish migrations. (Courtesy Jerry Knotts.)

WEDDING DAY. Frank and Edith Lucas pose on their wedding day on April 22, 1920. Frank Lucas was born in San Luis Obispo and raised in Los Alamos. Lucas moved to Nipomo in 1919 after fighting in World War I. He became a renown community member when he purchased the Dana Mercantile Company building. He was the beneficiary of early bonuses given out to World War I veterans by Congress and the FDR Administration in 1936, which he used to purchase the store. (Courtesy Jerry Knotts.)

WAITING AT THE PCR. Frank Lucas poses with two unidentified girls at the Pacific Coast Railroad Station in this c. 1920 photograph. It appears as if he was going somewhere since a suitcase is sitting in the background. (Courtesy Jerry Knotts.)

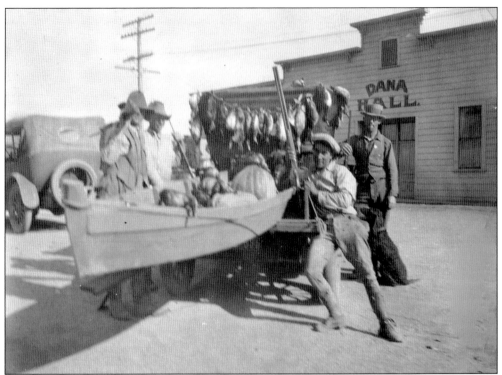

BOUNTIFUL HARVEST. From left to right, Frances and Ernest Jensen, Leo Leitner, and Frank Lucas demonstrate their hunting and gathering skills. Numerous ducks hang from the back of a car, while a boat holds pumpkins and other squash. The men are in front of Dana Hall, which was located on Dana Street. (Courtesy Jerry Knotts.)

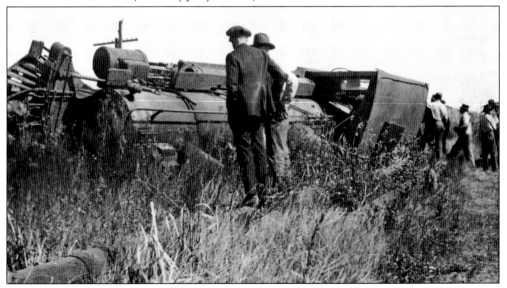

DERAILMENT. The Pacific Coast Railroad experienced a disaster in this c. 1920 photograph. The locomotive derailed on the north end of the Nipomo valley. When word of the train issue got out, spectators descended on the scene. Reportedly, even elementary school children were excused from school early so they could walk to see the mess for themselves. (Courtesy Jerry Knotts.)

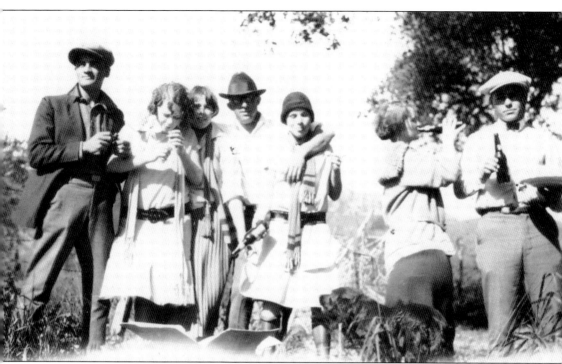

NAUGHTY IN NIPOMO. This prohibition-era photograph demonstrates the availability of alcohol during the 1920s. Reportedly, there were several speakeasies in downtown Nipomo, making alcohol easy to come by. Frank Lucas (center left), his dog, and his friends appear to be having a good time during an afternoon in Nipomo. (Courtesy Jerry Knotts.)

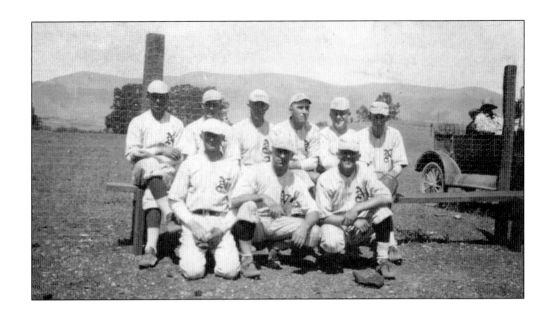

NIPOMO'S BASEBALL TEAM. America's national pastime initially came to California with American troops during the Mexican-American War in the 19th century. The troops who helped with conquest and occupation first played the game locally in Santa Barbara. As early as 1898, San Luis Obispo newspapers contain accounts of rivalry between the various teams around the county, including Nipomo's team. (Both, courtesy Jerry Knotts.)

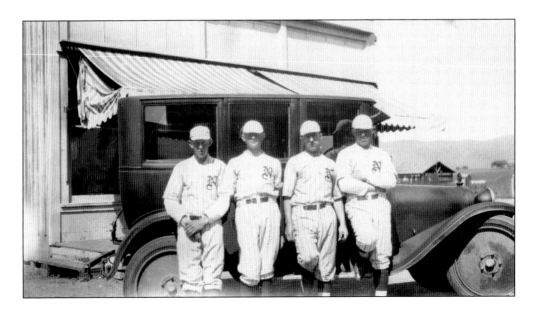

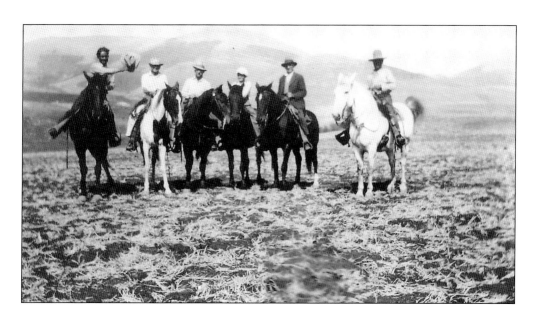

NIPOMO TRAIL RIDE. Riding through the ranch land of Nipomo was one of the traditional leisure time activities of Nipomo residents. They usually included an abundance of food and drink. Pictured above in this c. 1930 photograph (from left to right) are Kenny Adam, Pat Wineman, Frank Lucas, Vernon Wineman, an unidentified rider, and Del Villa. Below is a trail ride gathering on the Wineman Ranch, which was taken around 1930. In the center of the image are Pat Wineman and his two daughters. (Both, courtesy Jerry Knotts.)

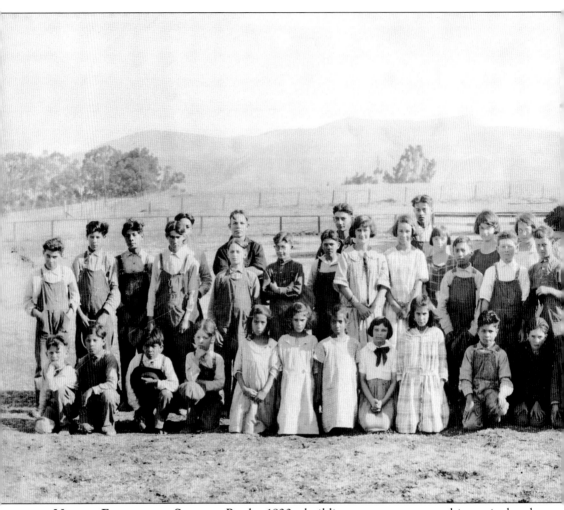

NIPOMO ELEMENTARY SCHOOL. By the 1920s, buildings were constructed in revival styles, demonstrating a renewed interest in history. One example is the new Nipomo School, built in the Mission Revival style, celebrating the area's past. Nipomo School's class stands in front of their school. Pictured from left to right are (first row) Pat Knotts, Fernando Corella, Manuel Martinez, George Dana, Angela Moreno, Rosie Dutra, Dorothy Moreno, Viald Riccho, Eva Dutra, Leslie Tanore, Charles Clark, Ramon Bischo, Birdie Tanore, Keith Holloway, Dorothy Jensen, Doris Holloway, Pearl Truitt, Kenneth Smith, Joe Shiffrar, Margaret Corella, Manuel Lonore, Frances Slater, David Dana, Basil Martinez, Margaret Wineman, and Juanita Lonore; (second

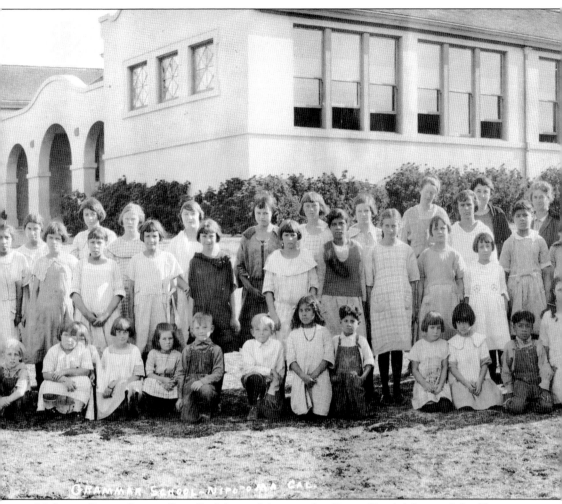

row) Johnnie Dutra, George Corrells, Johnnie Martinez, Joe Dutra, Frank Moreno, John Slater, Denny Wineman, Richard Romatio, George Knotts, Tony Soares, Adela Knotts, Karen Jensen, Tony Lopez, Lucille Lectiery, Andrew Moreno, Clarita Dana, Erla Slater, Dorothy Jensen, Hazel Smith, Irene Gamboa, Mariel Clark, Lonnie Smith, Loreta Louore, Gene Wineman, Rebecca Brown, Mrs. Catherine Dana, Kathleen Slater, Pearl Clark, Miss Ramona Sanford, Irene Eocs, Edyth Corella, Miss Marie Dana, Denise Cachman, and Mary Gellelatte. (Photograph courtesy History Center of SLO County; roster courtesy Jerry Knotts.)

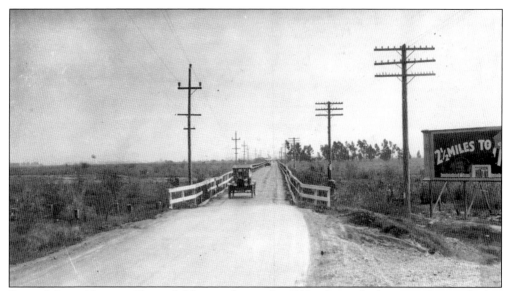

SANTA MARIA TRESTLE. To reach Nipomo during the 1920s, drivers had to cross the trestle that traversed the Santa Maria River. (Courtesy Caltrans.)

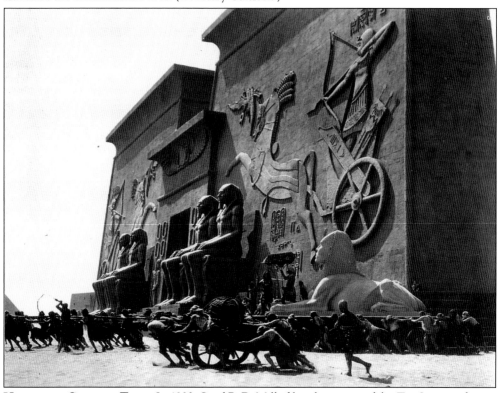

HOLLYWOOD COMES TO TOWN. In 1923, Cecil B. DeMille filmed portions of the *Ten Commandments* in the nearby Guadalupe-Nipomo Dunes. He chose the dunes complex because of its resemblance to the Egyptian desert. Along with DeMille came 1,600 workers, requiring entire temporary towns to form. After filming, the workers buried the set in the sand. The area is now an archaeological site. (Courtesy Guadalupe-Nipomo Dunes Center.)

Three

THE GREAT DEPRESSION

According to the US Census, approximately 1,812 residents lived in Nipomo in 1930. This number would increase exponentially each spring with the coming of migrant farm workers to pick the pea crop growing in the thousands of acres surrounding the town. This growth caused conflict, not only in Nipomo, but in the rest of the state as well. During the 1930s, California employed 4.4 percent of the national agricultural workforce, but nearly all of the agricultural labor strikes that took place in the nation were in California. The national spotlight looked at Nipomo as an example of such conflict.

Initially the effects of the 1929 stock market crash and the subsequent national economic downturn did not affect local towns as severely as other portions of the country because this was an agricultural region and people still needed to eat. However, by the mid-1930s, waves of immigrants escaping from the Dustbowl in the Midwest found themselves lured to Nipomo (estimated at 10,000 by a 1934 *Tribune* article) by advertisements appearing in national newspapers calling for laborers to pick the peas growing in the region. Many went on strike for better working conditions and an increase in the mere cents they received (25¢ per large basket) for all-day backbreaking work. Thousands of refugees descended upon Nipomo hoping for work. For several years, frost killed the spring pea crop and stranded the destitute workers. People from many races and nationalities were all stuck in Nipomo, unable to move on without earned income. The federal government finally intervened, first by sending a photographer by the name of Dorothea Lange to the town to document the labor surplus and starvation that was taking place. Soon President Roosevelt's Federal Emergency Relief Administration (FERA) stepped in to build facilities, such as schools and bathrooms, to meet the basic needs of the migrant farm workers. Nipomo was in the national spotlight nearly every spring during the 1930s, which often attracted photographers and artists that made the public aware of the poor living conditions. The Dustbowl immigrants also changed local culture and customs as they brought political ideology, food, and religion with them.

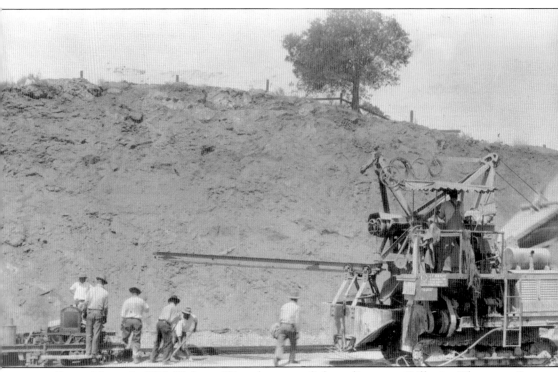

FOOTE MIXER. In 1930, Highway 101 underwent a slight realignment. Still using Thompson Street as the main highway, workers straightened out some of the curves in the road. Pictured here is a Foote mixer—a predecessor to the modern cement mixer. Created by Foote Manufacturing Company in New York, originally the mixers were attached onto the back of cars. This one appears to move more like a tank. The mixers were the first to use automatic measuring devices to combine sand and stone before dumping the mixture into the desired place. Construction workers utilized these machines while building Highway 101, the road in which all commerce and travel would be dependent. Cement created using Foote mixers can still be seen around Thompson Street today. (Courtesy Caltrans.)

HIGHWAY LABOR. By 1930, many of the laborers in San Luis Obispo County were Filipino immigrants. Not only did these immigrants work in agriculture, but they also helped build local roads. These men appear to be installing a drainage system under the realigned Highway 101 that was constructed in 1930. (Courtesy Caltrans.)

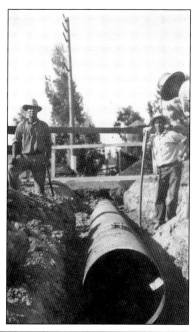

US CENSUS, 1930. This page from the 1930 census shows the diversity of the people living in Nipomo during the period. A large portion of the workforce came from the Philippines, a US possession at the time. The majority of the recruited laborers were single men, hired to work in the fields when people of other nationalities were banned from immigrating to the country. Earlier Japanese immigrants remained in Nipomo even after the ban on immigration. (Courtesy US Census Bureau.)

PEA PICKERS, 1932. The year 1932 saw one of the highest unemployment rates during the Great Depression at 23.6 percent. That same year the National Weather Service reported 14 dust storms in the Midwest, in what would turn into a natural disaster for years to come. At the national level, this resulted in the election of Franklin Delano Roosevelt. For the quaint and rural Nipomo area, this meant the beginning of an influx of immigrant workers from the affected areas that hoped to find work in the agricultural sector. This photograph shows some of the first pea pickers that arrived in the region. (Courtesy Caltrans.)

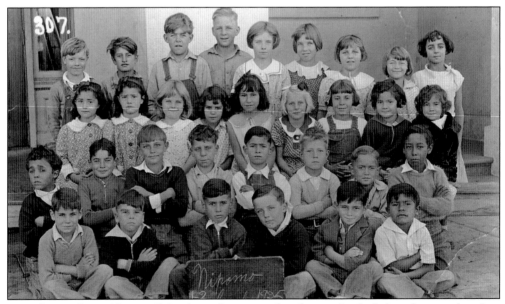

FIRST GRADE CLASS. Nipomo School grew large enough to have individual class photographs taken by the 1930s, rather than a single picture taken of the entire school population. Pictured here is the school's 1935 class of first and second graders. (Courtesy History Center of SLO County.)

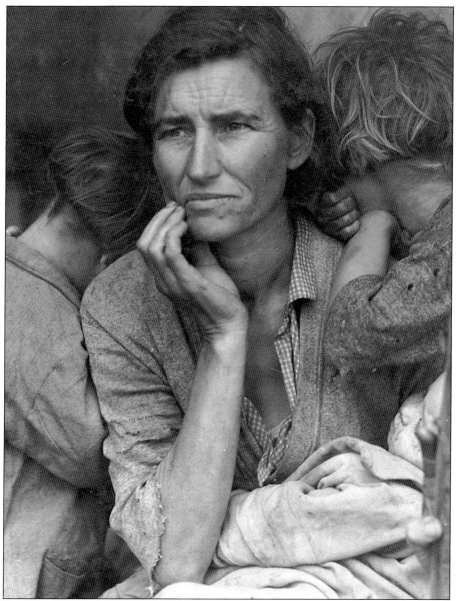

MIGRANT MOTHER. Nipomo's most famous image is probably that of Dorothea Lange. She captured Florence Owens Thompson in 1936 for the New Deal's Resettlement Administration (later known as the Farm Security Administration). Lange's job was to document the economic and social hardships resulting in the mass migration of people to California. The photograph became known as "Migrant Mother" even though Thompson had reportedly been living in California for a decade when it was taken, according to some accounts. This photograph made Lange famous and appears in many history textbooks around the nation today. It gave a face to people living during the Great Depression, exposing people living around the nation to the plight of the Dustbowl migrant. It also served as the inspiration behind the naming of Dorothea Lange Elementary School in Nipomo. Shortly after taking this photograph, Lange retouched it in order to erase the finger in the foreground, which is how it most often appears today. (Courtesy Library of Congress.)

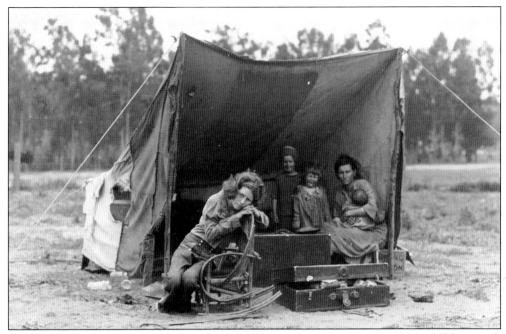

Owens From Afar. Lange took a series of six photographs of Thompson and her children, each one getting closer to the family. The Library of Congress never received the last in the series, although Lange's husband published it in 1970. In the background are eucalyptus trees that are still visible in Nipomo today. (Courtesy Library of Congress.)

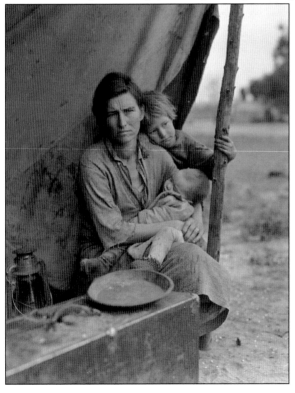

Supporting a Family. Thompson reportedly told Lange that her family had been surviving by eating frozen vegetables from the surrounding fields and birds that the children managed to capture. Owens sold the tires from her car to buy food and subsequently fed her family using vegetables from the pea plants that were destroyed during the frost that year. (Courtesy Library of Congress.)

MIGRANT CAMPS. Thompson and her family were in a camp with 2,500 other migrant workers that came to Nipomo to pick peas in 1936. There were also camps in other parts of Nipomo, including the edge of the Mesa and near today's Native Garden, where even more migrant workers were reportedly located. However, the pea crop that these workers came to pick failed due to poor weather conditions. All of the workers were stranded, which left county, state, and federal government officials scrambling to help and/or forcibly move the migrants to other areas. (Courtesy Library of Congress.)

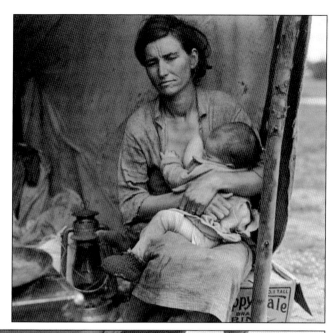

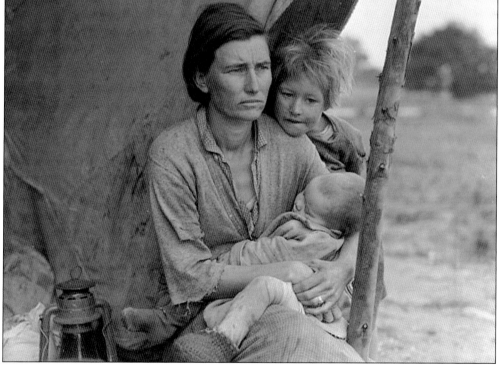

ENCOURAGING CHANGE. Regardless of the circumstances behind the photographs, the series helped many people throughout the United States. Lange's photograph of Thompson provided a catalyst for change. It brought national attention to the plight of the Nipomo pea pickers. The federal and state governments stepped in and provided aid to the stranded workers. Government agencies gave food to the migrant workers, established buildings for use a school and hospital, and built a pump to provide fresh drinking water. (Courtesy Library of Congress.)

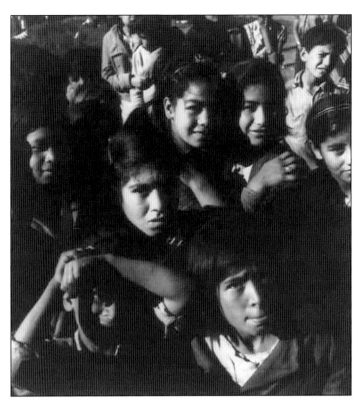

MEXICAN PEA PICKERS' CHILDREN. Dorothea Lange produced this photograph in 1935 during one of her first trips through Nipomo. Often, farm workers were segregated into camps by race, which the children in this photograph demonstrate. Organizations such as the League of Women Voters came to Nipomo to establish schools for the children, who accompanied their parents into the camps. (Courtesy Library of Congress.)

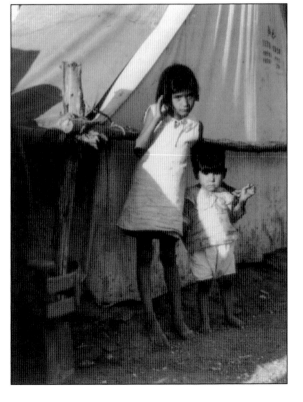

MALNOURISHED CHILDREN. Dorothea Lange also took this photograph during her 1935 tour of Nipomo. She lists these pea pickers' children as being malnourished. They appear to be standing in front of a tent that US government agencies provided to combat the poor living conditions that migrant farm workers were forced to live in due to the economic climate of the period. (Courtesy Library of Congress.)

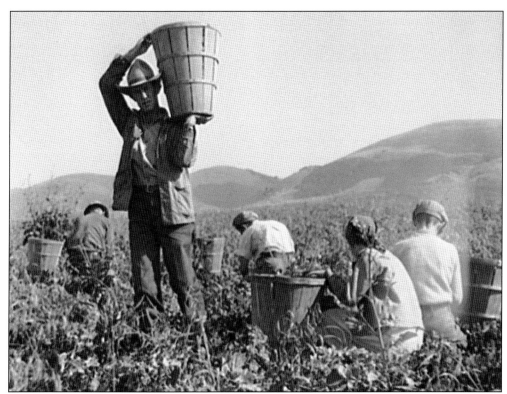

FAMILY WORKING TOGETHER. A family toils together in Nipomo's pea fields during Dorothea Lange's 1937 trip to the town. Families, such as this one, were what John Steinbeck based his novel *The Grapes of Wrath* on. In the background are Nipomo's famous hills. (Courtesy Library of Congress.)

FARMER TURNED FARM LABORER. Environmental degradation and poor economic conditions forced many people to flee their farms in the Midwest during the 1930s. People that had once owned their own farms had to begin working as laborers. Pictured here is one of the many people that found themselves in Nipomo's agricultural fields due to the Dustbowl. (Courtesy Library of Congress.)

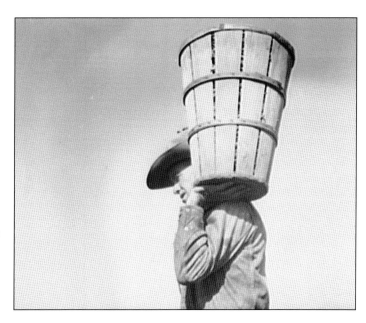

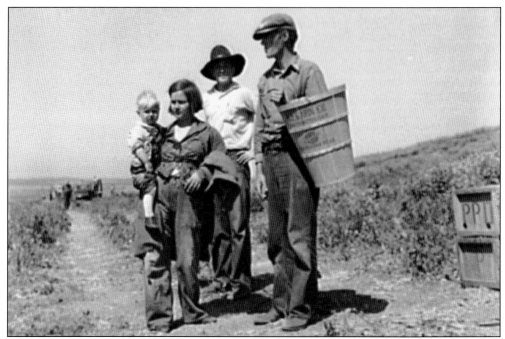

REFUGEE FAMILY FROM OKLAHOMA. Filling a large basket with small peas proved to be a difficult task, so families worked together to more efficiently fill the baskets and earn more pay. Often, pickers had to buy their baskets from the farmer, and would sometimes repeatedly use the same basket at different locations. This particular basket appears to be from a farm called A.E Garin Co. (Courtesy Library of Congress.)

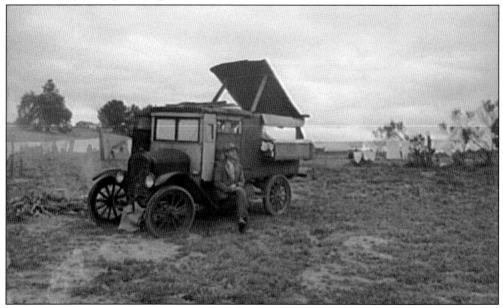

A PEA PICKER'S HOME. This person made his home a half-mile off Highway 101, now Thompson Street. Dorothea Lange took note in 1937 that many people were living in their cars due to the lack of funds for housing and the need for mobility to move to various fields as crops came into season. Clotheslines surround his car. (Courtesy Library of Congress.)

A Texas Tenant Farmer. The majority of farmers in the Dustbowl area were former tenant farmers, meaning they rented the land they farmed at the locations of their prior home. They paid rent with crops or the cash that they earned by selling the crops they grew. The Dustbowl spelled disaster for tenant farmers, many of which found their way to Nipomo's fields to try to make a living. (Courtesy Library of Congress.)

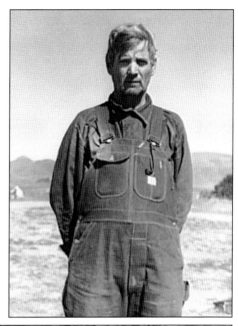

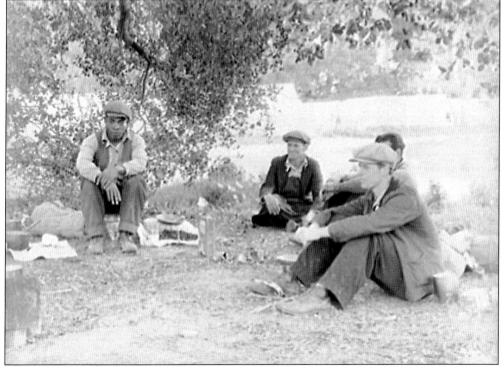

Single Men by the Roadside. The Great Depression witnessed many men leaving their families to search for work. These men often found themselves in Nipomo, changing the dynamics of families during the period. Nipomo's agricultural fields brought people of different genders and different ethnic backgrounds together depending on personal circumstance and culture, but all of them hoping to make a living during tough economic times as is shown in this 1935 photograph. (Courtesy Library of Congress.)

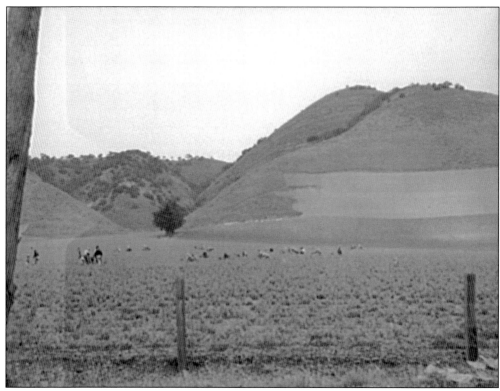

Filipino Laborers. In February 1936, Dorothea Lange took note of Filipino "gang labor" that worked on Japanese-owned farms. During the 1920s, anti-immigration laws created a shortage of farm labor that farmers and labor contractors filled with Filipinos. Labor contractors recruited Filipinos from the Philippines and Hawaii to work in the United States, many of which ended up in Nipomo as they followed the planting and harvesting of crops up and down the West Coast. (Courtesy Library of Congress.)

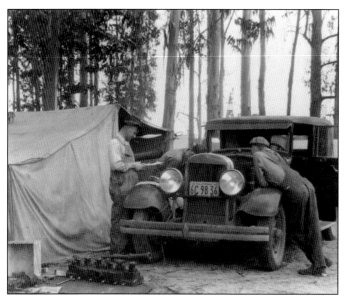

Pea Pickers from Vermont. People came from around the nation to work in Nipomo. Dorothea Lange captured these pea pickers from Vermont who reported that they made a mere $7 during the entire six weeks they worked in Nipomo's fields. It appears that the workers experienced car trouble, which could mean disaster for those living on such low pay. Visible in the background again are Nipomo's famous eucalyptus trees. (Courtesy Library of Congress.)

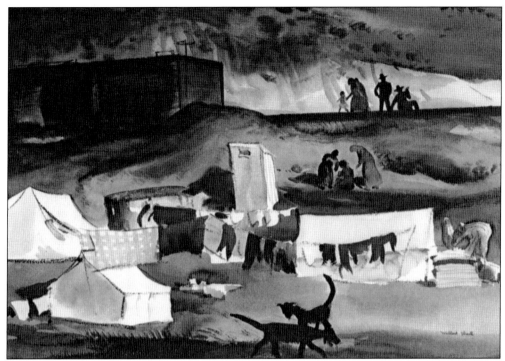

MILLARD SHEETS PAINTING. During the Great Depression, many artists evolved from following European art movements to becoming aware of regional social issues. Millard Sheets was one of the leaders of the California Style watercolor movement, and helped organize the WPA to employ artists. This painting, created in 1936 at the height of the migrant worker issues attempts to demonstrate the living conditions in the camps. The caption that appeared with the painting stated, "Near Nipomo: Back in Dakota we had a house and ground and all. But that was before the dust." The painting appeared in *Fortune* magazine in 1939. (Courtesy DANA.)

MILFORD ZORNES PAINTING. Milford Zornes moved to the local area during the 1920s to attend Santa Maria Junior College (now Allan Hancock College) and major in journalism. Later, he moved to San Francisco to attend Otis Art Institute where he met Millard Sheets. Zornes, like Sheets, was part of the California movement. Many specialized in watercolor during the Depression because of its availability, cost, and portability. Zornes's art is in the Smithsonian and among other major collections. The Dana Adobe appears in this painting. (Courtesy DANA.)

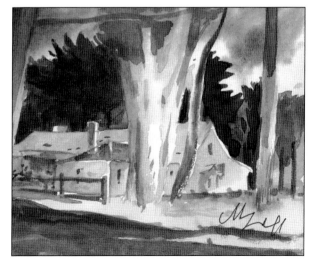

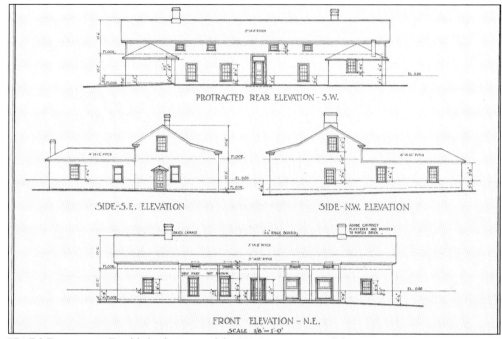

HABS BLUEPRINT. Established as part of the US Department of the Interior in conjunction with the National Park Service during the 1930s to combat the effects of the Great Depression, the Historic America Buildings Survey (HABS) employed out-of-work engineers and architects to locate and map historic structures that demonstrated achievement in architecture, engineering, and design technologies. This included the Dana Adobe in Nipomo; a survey crew created these detailed blueprints of it in December 1936 and January 1937. (Courtesy Library of Congress.)

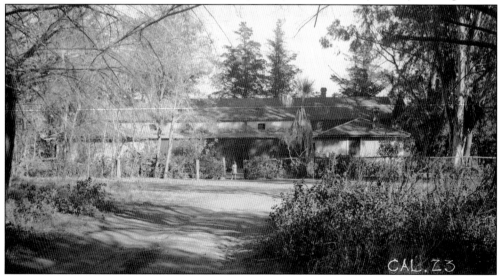

HABS PHOTOGRAPH. The HABS also produced a series of eight photographs for their documentation. Pictured here is the Dana Adobe during the 1936–1937 survey. The document lists the adobe as being under the ownership of Helen Grisengher of Guadalupe and "occupied but in poor condition." An unidentified girl holding her pet cat is present in the center of the photograph. (Courtesy Library of Congress.)

ROSE GARDEN. This 1933 photograph of the adobe shows a woman and her dog standing in the adobe's courtyard. It appears that they are both trying to catch a gopher in the garden—a scene that appears in many yards of Nipomo residents to this day. It seems as if the gopher won the battle, as the rose garden does not appear in later photographs of the adobe. (Courtesy History Center of SLO County.)

THE ALLEN FAMILY. Among the many immigrants to Nipomo during the Dustbowl period were the Allens from Austin and Fort Worth, Texas. From left to right, the adults in this photograph are Cecil Margaret Garner (wearing her uniform from her nursing job at the Catholic hospital in Santa Maria), Ures Clyde, Charlie Cleveland, Claudia Maybelle, Thomas Hubert, and Dorothy Lorena. (Courtesy Denise Goodwin.)

WINE DINNERS BEER

DOUGHTY'S CAFE
101 HIGHWAY
NIPOMO, CALIFORNIA

HOME COOKING
—Open Nights To Accommodate You—

DOUGHTY'S CAFÉ. A favorite community-gathering place in the 1930s was Doughty's Café. The restaurant was located in the current location of the Hart Velo bicycle shop on Thompson Street. During the 1940s, it became Jack and Lavelle's Café, the namesake of the couple that purchased the restaurant. (Courtesy Jerry Knotts.)

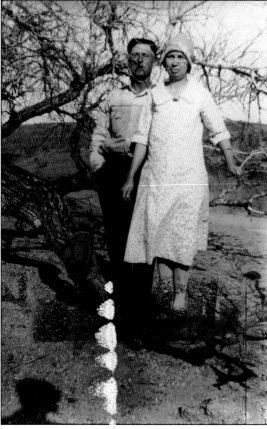

ARRIVING IN NIPOMO. Ballard Auburn Garner and Polly Remilla Ann Potter Garner pose together upon their arrival to Nipomo from Texas during the early 1930s. (Courtesy Denise Goodwin.)

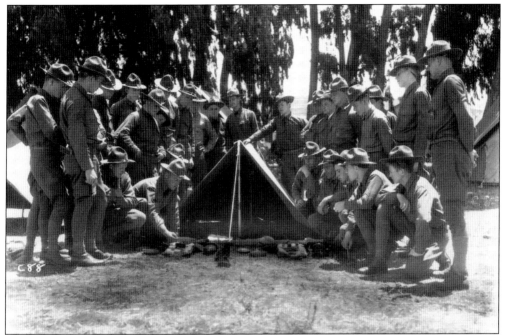

NIPOMO WAR GAMES. The 1930s also saw the military descend upon Nipomo. During the interwar period, the military organized groups that came to Nipomo to practice maneuvers, called the Nipomo War Games. It was the largest assembly of military personnel since World War I. The men organize their weapons in front of a tent in this picture in 1935. (Courtesy History Center of SLO County.)

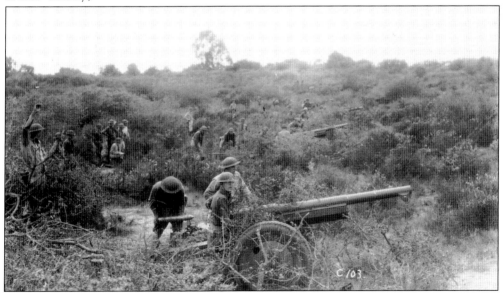

"RED" TROOPS. The 145th Artillery was divided into groups to battle one another, this group being the Red Group that gathered in Los Angeles under Gen. Walter Story. The Blue Army organized in San Francisco and was commanded by Gen. Wallace A. Mason. The two groups met in the middle and practiced field maneuvers. The purpose was to practice moving detachments by motor transport. (Courtesy History Center of SLO County.)

GOVERNOR'S VISIT. The practice lasted from July 14–19 and contained thousands of small skirmishes on the Nipomo Mesa. California governor Frank Merriam (left) shakes hands with an unidentified man during his visit to Nipomo during the war games. Merriam is famous for defeating Upton Sinclair during the 1934 election. He took office after his predecessor, James Rolph, died in office. (Courtesy History Center of SLO County.)

FIRE TRUCK. Frank and Muffy Muñoz pose with Nipomo's 1939 fire truck in front of the Lucas Store. The truck was part of the fire station that was located on Tefft Street east of Thompson, and was the town's second vehicle dedicated to fighting fires. In the background is the old Western-style building that stood next to the Lucas Store, with posters plastered on its side announcing the arrival of the circus, with the famous Clyde Beatty as a main act. (Courtesy Jerry Knotts.)

Four

CONTINUITY AND CHANGE

The end of the Great Depression brought about a period of both change and continuity for Nipomo. Like the rest of the nation, the town had several of its residents fighting in World War II. While the men were at war, the women of the town contributed to the effort in every way possible by rationing and collecting donations for the cause.

Many times modernization and development came at the expense of what came before. Increased automobile ownership caused the need for better roads. The Federal Interstate Highway System moved traffic at faster speeds along a more direct route in the form of Highway 101 as we know it today. That meant less traffic along Thompson Street and the movement of businesses closer to the freeway. It also meant better transportation for residents and ease of shipment for goods in and out of the area. Farms that supplied the nation with food evolved into subdivisions, development, and population growth.

Agriculture continued to play a major role in the local economy but also experienced change. Various groups of immigrants, as well as differing American tastes, resulted in the change of the types of crops grown locally. The popularity of cabbage increased with the increase in Asian immigrants, while chili peppers became more prominent with Mexicans and Mexican Americans. Perhaps the greatest transformation of all was the strawberry crop. Virtually unseen around the 1900s, by the end of the century Nipomo, along with neighboring Santa Maria, became one of the top global strawberry-producing regions.

The postwar period also saw a renewed interest in historic preservation. The San Luis Obispo County Historical Society saved the neglected Dana Adobe from collapse, at a time when many other local historical homes lacked such luck. Many community members came together to contribute to the restoration effort.

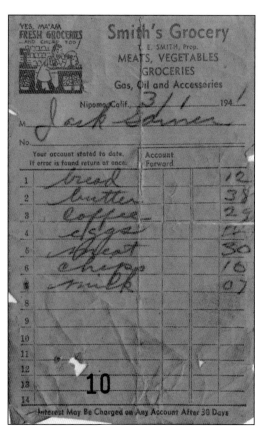

Smith's Grocery Receipt. Smith's Grocery was located along Thompson Street. In 1941, Jack Garner purchased goods from the store. Included in the receipt is bread for 12¢ and coffee for 29¢. (Courtesy Jackie Gracia.)

Flood. The year 1941 saw torrential downpours that infrastructure could not handle. This photograph was captured on April 4, 1941. The Santa Maria River Bridge was constructed out of wire and logs. Spring rain flooded the river and the bridge prevented the river from properly flowing. (Courtesy Caltrans.)

WORLD WAR II IN NIPOMO. The old post office that was located behind the Lucas Store contained Nipomo's Honor Roll—those that valiantly fought for their country in World War II. Hazel Muñoz dutifully stands at her post awaiting the next customer. (Courtesy Jerry Knotts.)

THE HOME FRONT. Nipomo had its own float in the Santa Maria Rodeo Parade. During World War II, the women who were left on the home front used the parade as an opportunity to collect aluminum for the war effort. People could run up to the float that was painted with the words "Nipomo Aluminum-4-Defense" and give their cans to the women. (Courtesy Jerry Knotts.)

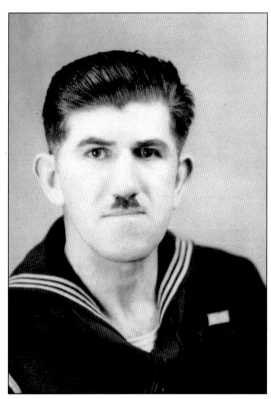

NIPOMO'S HEROES. Among the many residents that risked their lives for their country during World War II were Melbourne "Rocky" Dana (left) and Leonard Dana (below)—both descendants of William G. Dana and Maria Josefa Carrillo. (Left, courtesy History Center of SLO County; below, courtesy DANA.)

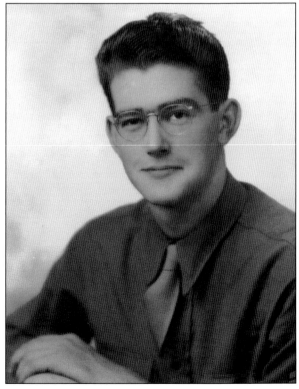

SWEETHEARTS. Lin Cooper, a US Marine during World War II, is sitting with his wife in this c. 1943 photograph. (Courtesy Denise Goodwin.)

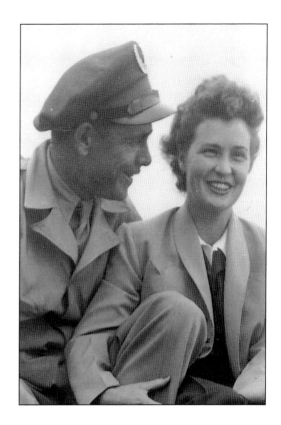

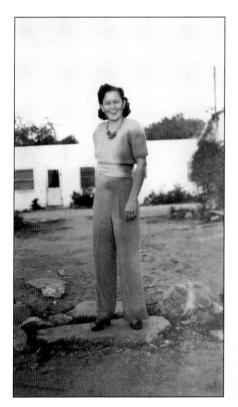

LAVELLE GARNER. In 1942, Lavelle Garner poses in front of buildings on Thompson Street. The buildings were "motor coaches," or temporary places people could stay while they worked in the area. On later maps, the buildings were referred to as apartments. Lavelle Garner was one of the owners of Jack and Lavelle's Café, which was located across the street from the motor coaches. (Courtesy Jackie Gracia.)

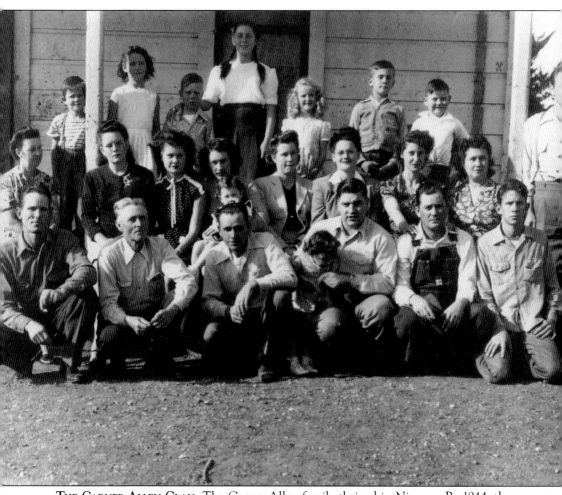

THE GARNER-ALLEN CLAN. The Garner-Allen family thrived in Nipomo. By 1944, there were 23 members who pose in front of their house in Old Town. From left to right are (first row) Ures Garner, Ballard Garner, Lin Cooper, two unidentified men and a child, and Ures Allen Jr.; (second row) Polly Barnum-Garner, an unidentified woman, Babe (Ellen) Garner, Jean Garner, Diana Mingles, Mable Garner, an unidentified woman, Evelyn Garner-Holloway, Cecil Garner-Allen, and Keith Holloway; (third row) Dennis Allen, Rita Allens-Martins, Jimmy Cooper, Patsy Wheate, Nina Holloway-Rollins, Wayne Allen, and an unidentified boy. (Courtesy Denise Goodwin.)

POSING. Evelyn Garner poses on her Uncle Ed's jeep while he was visiting from Texas. The photograph was captured near Oakglen Avenue. (Courtesy Denise Goodwin.)

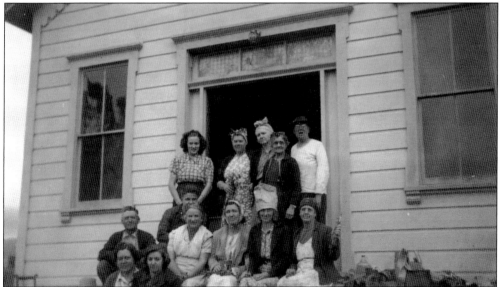

INTERIOR DECORATING BEE. The women of the Nipomo Community Presbyterian Church pose during their interior decorating and/or cleaning effort in 1940. Pictured, from left to right, are (first row) Polly Garner and Mariam Volk; (second row) Mr. Garner, Cora Volk, Lucille Washington, Mildred H., and Mary Zigler; (third row) Violet Hayes, Hazel Muñoz, Edith Smith, Sylvia Cotter, and Mr. Marshburn. (Courtesy Nipomo Community Presbyterian Church.)

LADIES AID SOCIETY. A group of Nipomo women organized the town's Ladies Aid Society, who took the task of improving the town upon themselves. In 1945, they participated in a Red Cross drive to raise money for the war. Mattie Mehlschau and Mrs. Dan Sheehy are listed as being among the donors. (Courtesy Nipomo Community Presbyterian Church.)

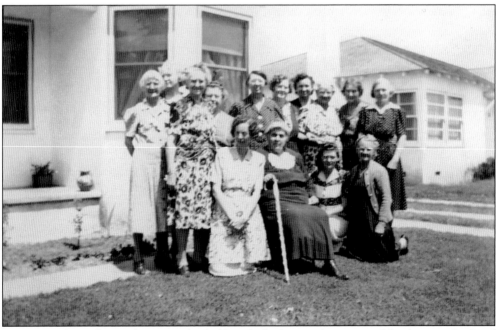

POTLUCK. The Ladies Aid Society also held potlucks for social events and fundraising. In April 1945, the local newspaper announced that Mrs. John Kehrer hosted the ladies, while Mrs. Sylvia Cotter conducted the business meeting on this particular day. (Courtesy Nipomo Community Presbyterian Church.)

SOCIAL HALL. Upon their return from war, the Ladies Aid Society put the men to work on community improvement. This photograph indicates that Mr. Volk, Mr. Zigler, and Clive Porter helped build the church social hall on November 11, 1947. The Nipomo Community Presbyterian Church used the building as a classroom. It was located near the church, which still stands today on Dana Street. (Courtesy Nipomo Community Presbyterian Church.)

NIPOMO GARAGE. On the corner of Tefft and Thompson Streets once stood Nipomo Garage, which also served as a gas station. The left portion of the building was a service station, while the right portion served as a bar. In front stand David Dana (left) and Jocko Knotts. Pepper trees in the back once covered an area to play horseshoes. (Courtesy Jerry Knotts.)

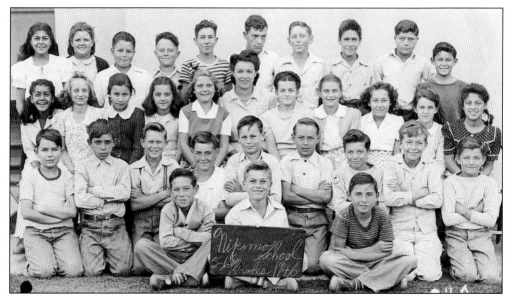

NIPOMO SCHOOL, 1940s. Similar to the 1930s Nipomo School class photograph, the fifth and sixth grade combination class poses for its annual school picture in 1946. Some things never change, as this fifth grade report card demonstrates. Even in 1945 teachers noticed their students' short attention spans just as they do today. (Above, courtesy Jerry Knotts; below, courtesy Denise Goodwin.)

Rita

	1	2	3	4	5	6	TEACHER'S COMMENTS
Reading { Comprehension	S-	S	S	S	S	S	Rita has the ability
Reading { Oral	S-	S-	S-	S-	S-	S-	to do better work as
English Expression { Language	S	S	S-	S-	S-	S	soon as she forgets
English Expression { Written	S-	S-	S-	S-	S-	S-	other people around h
English Expression { Spelling	S	S	S	S	S	S-	
Arithmetic { Reasoning	S-	S-	S-	S-	S-	S	
Arithmetic { Fundamentals	S	S-	S-	S	S	U+	
Social Studies { Civics							
Social Studies { History	S-						
Social Studies { Geography	S	S	S	S	S	S-	
Penmanship	S	S	U+	S	S-	S	
Health Education	S						
Art	S	S	S-	S-	S	S-	
Music	S	S	S	S	S	S	
Physical Education	S	S	S-	S	S-	S	
Natural Science	S			S-	S		
Conduct	S-	S-	S-	S-	S	S	
Effort	S-	S	S-	S-	S	S-	

No. Days at School	28½	27	30	26
No. Days Absent	½	±	0	0
Times Tardy	0	0	0	0

MEANING OF RATINGS
S- Satisfactory
U- Unsatisfactory
F- Failing

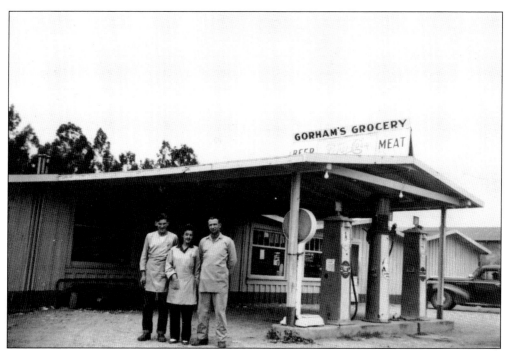

GORHAM'S GROCERY. In 1946, this photograph was taken of Mr. and Mrs. Ferrin and their son. They are standing outside of the grocery store reportedly located along Thompson Street. (Courtesy History Center of SLO County.)

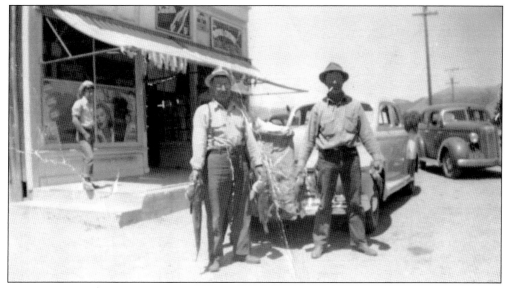

SHOWING OFF. There are no fish stories here, as Frank Lucas (left) and Donald Phelan show off their catches in front of the Lucas Store during the 1940s. They most likely caught these fish out of Avila. (Courtesy Jerry Knotts.)

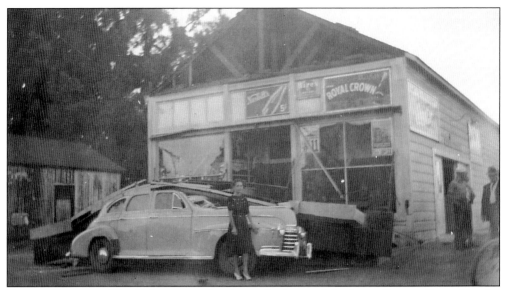

FACADE COLLAPSE. The 19th-century facade on the front of the Lucas Store collapsed in the mid- to late 1940s. Edith Lucas stands beside her relatively new car. She was reportedly one of the only Nipomo residents able to purchase a new car during World War II due to wartime rationing. The building still stands on the corner of Dana and Thompson Streets, but it stands without a facade because of this unfortunate event. (Courtesy Jerry Knotts.)

JOCKO AND MOLLY. Ralph "Jocko" Knotts, and his wife, Molly, pose for this photograph during the 1940s. The legendary Jocko passed away in 1952, unfortunately never able to see today's Jocko's location built in 1962. However, he will always be remembered because of the restaurant that bears his name. (Courtesy Jerry Knotts.)

THE SHEEHY BROTHERS. From left to right are Gerald Sheehy, Dan Sheehy, and Jocko Knotts. They are standing on the corner of Tefft Street and Thompson Street. Visible in the background is the house and redwood tree that still stand near Jocko's Steakhouse. Mollie Knotts lived in the house during the early years and was famous for her Christmas decorations, but today it serves as the restaurant's office. (Courtesy Jerry Knotts.)

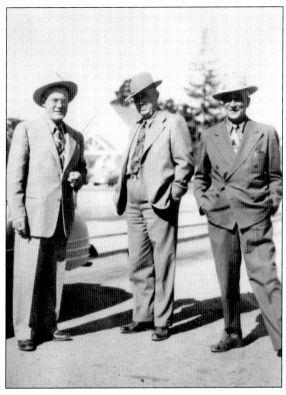

HOMEMAKING. Evelyn Garner-Holloway is working in her kitchen, possibly making biscuits, in this c. 1950 photograph. Her house was located on Oakglen Road and still stands today. (Courtesy Denise Goodwin.)

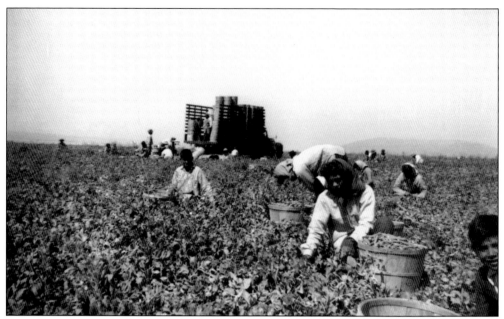

FARM WORKERS. From the town's beginning, migrant workers have called Nipomo home. After the Great Depression ended, farmers turned to Mexico for labor through the Bracero Program. The program allowed farmers to import contract laborers to pick the labor-intensive crops growing in the region. Above, workers pick peas in 1946; below, they pick beans in 1953. (Both, courtesy History Center of SLO County.)

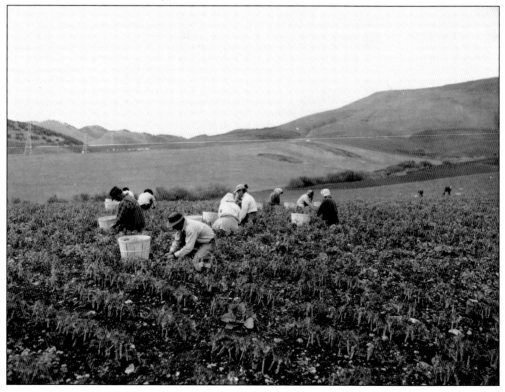

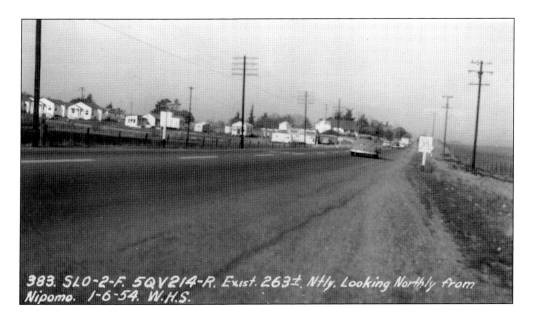

383. SLO-2-F. 5QV214-R. Exist. 263± Ntly. Looking Northly from Nipomo. 1-6-54. W.H.S.

THOMPSON STREET. In 1954, Caltrans documented Thompson Street. Looking north from Nipomo, houses along Bee Street are visible. Some of which are still standing today (above). Looking south, the local service stations and cafés are visible on the left, while the motor coaches are on the right. (Both, courtesy Caltrans.)

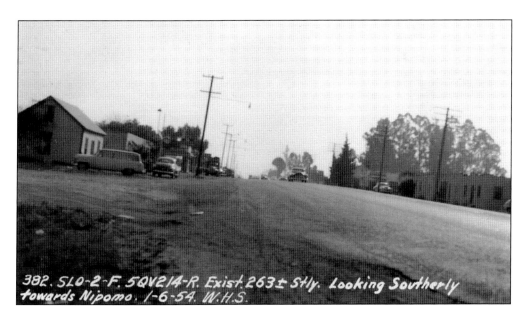

382. SLO-2-F. 5QV214-R. Exist. 263± Stly. Looking Southerly towards Nipomo. 1-6-54. W.H.S.

107

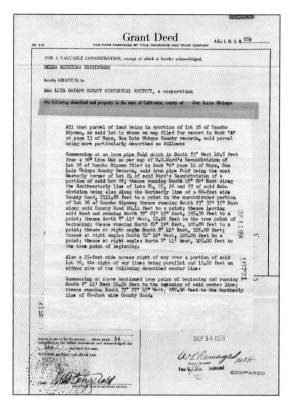

DEEDING THE ADOBE. On September 14, 1954, Helen Grisingher deeded the Dana Adobe to the San Luis Obispo County Historical Society, which is now the History Center of San Luis Obispo County. This enabled work to begin on the restoration process to build the house to its former glory. Later the historical society would donate the house to the Friends of the Dana Adobe for continued restoration. (Courtesy History Center of SLO County.)

OAKGLEN AVENUE. Driving down the road towards the Dana Adobe looked much differently in the late 1940s and early 1950s than it does today. It appears that most of the surrounding greenery consisted of cypress trees. (Courtesy Hal Baker and Maria Zornes Baker.)

EASTER. Every Easter after services, the Lucas Store served as the local gathering place. This March 1956 photograph shows the food and tea service that the Lucas family set out for the store's patrons. (Courtesy Jerry Knotts.)

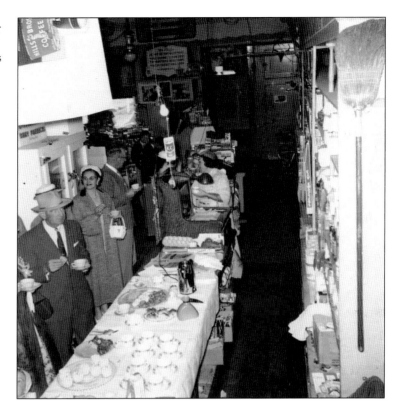

482. Slo-2-F. Nipomo Creek Overflow. 80±. 1-25-56. WWE.

NIPOMO CREEK OVERFLOW. The 1956 rainy season saw heavy flooding in the region. This appears to be the area where Highway 101 and the Santa Maria Speedway are located today. (Courtesy Caltrans.)

THE B. KNOTTS SALOON. Prior to the establishment of Nipomo's famous landmark, Jocko's Steakhouse, the Knotts family had separate establishments for food and cocktails. The saloon was located on the east side of Thompson until it burned in 1957. From left to right, Burnett Knotts is pouring drinks for Potter the butcher, Carl the barber, Dinney Sheehy, and Frank Lucas. (Courtesy Jerry Knotts.)

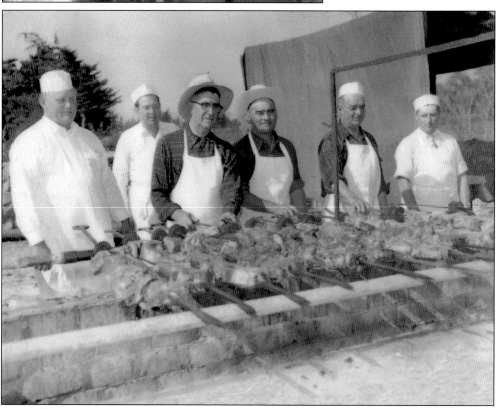

MEN'S CLUB BARBECUE. Preparing barbecue at the Nipomo Men's Club, from left to right, are M.J. Hermreck, George Knotts, O.R. "Chupie" Dana, Arthur Muñoz, Kenneth Dana, and Bob Toma during the late 1950s. (Courtesy Jerry Knotts.)

HALLOWEEN, 1959. Mrs. Nicholas Arellanes (left) and Mrs. James Flory hold a poster advertising the Nipomo School PTA Halloween Carnival on October 28, 1959. Janet Arellanes stands in front, dressed as a witch. (Courtesy History Center of SLO County.)

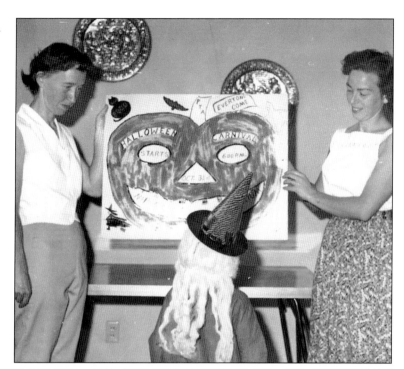

HORSEBACK. Nipomo's rancho period during the mid-19th century left its mark on the culture of the region. CJ Pat Ford demonstrates this as he rides his horse through the town. (Courtesy Nipomo Men's Club.)

EMERGENCY RELIEF. People that came to Nipomo to work in the area's fields continued to experience disaster, similar to that of the Depression. This time, however, state and federal agencies were better prepared to step-in and help those in need. In March 1958, their camp flooded when a heavy storm struck the region. Below, an emergency school was built in Nipomo so that children could receive educations while their parents work. (Both, courtesy History Center of SLO County.)

HARVESTING, 1960. Several children are seen participating in the harvest in Los Berros at the Grieb Orchard. Mostly likely, the children were there for a school field trip or another leisurely activity, as they appear to be having more fun than would be normal for doing required chores. At right, Joan (left) and Denise Phelan pose with string beans. Below, several unidentified children help cut apricots. (Both, courtesy History Center of SLO County.)

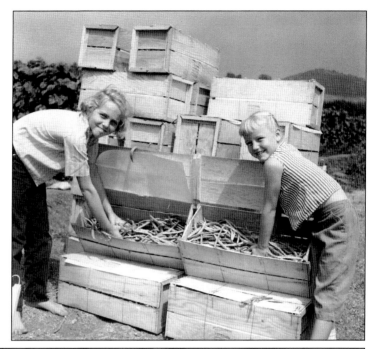

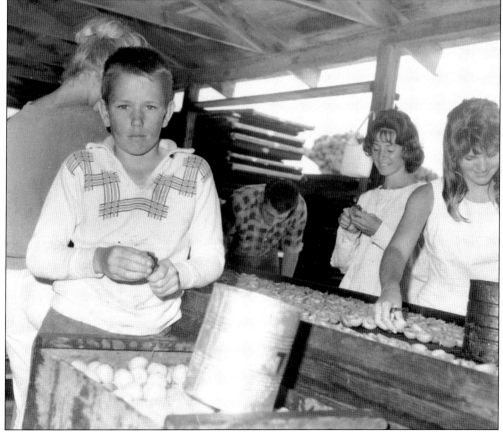

RENEWAL AND RESTORATION. Years of neglect took their toll on the Dana Adobe. The north wing of the house was collapsing by the 1960s and 1970s, making the meticulous restoration taking place today look astonishing. Volunteers worked on the house to prevent further decay. This included Boy Scout Troop 29 of Arroyo Grande, which spent January 26, 1963, at the adobe. (Both, courtesy History Center of SLO County.)

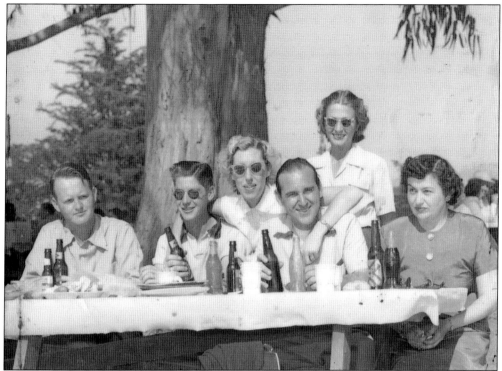

EVENTS. In addition to the annual buck contest and the weekly dinners, the men's club hosted many events like the organization still does today. Above, several unidentified young people enjoy a picnic. Below, several children wait their turn to ride a horse led by Frank Middleton. (Both, courtesy Nipomo Men's Club.)

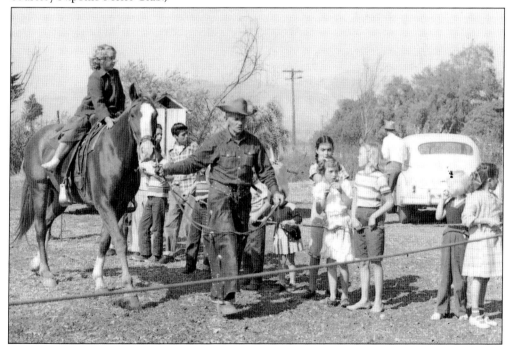

PARKING LOT. Jim Dunn and Justine Toomey stand in the men's club parking lot during one of the many club events. (Courtesy Nipomo Men's Club.)

RODEO QUEEN NOMINEE. Donna Reed poses of her portrait when she represented Nipomo in the annual Santa Maria Elks Rodeo. In the past, the men's club at the Nipomo Recreation Center would both have nominees for the event. Local nonprofits sponsor high school and college age girls who are responsible for coordinating fundraising efforts to help raise money that is then distributed throughout the community. (Courtesy Nipomo Men's Club.)

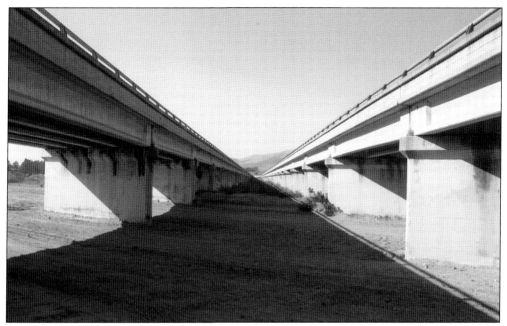

SANTA MARIA RIVER BRIDGE AND LEVEE. The federal government stepped in to increase the size and traffic capacity of Highway 101. The twin bridges that span the Santa Maria River were built in 1962 and were part of the project allowing traffic to flow more smoothly and rapidly through the area. The levee that serves as the boundary between San Luis Obispo and Santa Barbara Counties was also constructed in 1962. The US Army Corps of Engineers constructed the structure out of rock and sand. However, after Hurricane Katrina in 2005, the federal government assessed the stability of levees nationwide, and found the Santa Maria levee was at high risk of failure. Funds to rebuild the levee were made available in 2009 through the American Recovery and Reinvestment Act with the help of Representative Louis Capps in an effort to prevent future flooding and higher flood insurance premiums for nearby residents. (Above, photograph by Doug Jenzen; below, courtesy Caltrans.)

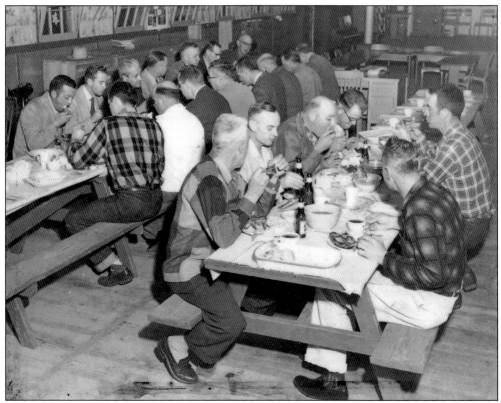

MEN'S CLUB MEAL. Typically, men's clubs around the nation were formed as social groups to sponsor civic, social, and morally positive community activities. The local men's club meets in a former barracks building from Camp San Luis Obispo. After World War II, several members dismantled the building and rebuilt it in Nipomo where it stands today. Pictured here are many members enjoying their meal. (Courtesy Nipomo Men's Club.)

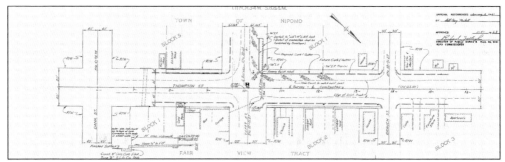

OLD TOWN CONSTRUCTION. In 1962, San Luis Obispo County created this map and accompanying plans for curbs and gutters along Thompson Street in Old Town Nipomo. Shown on this map are structures that existed at the time, including the Nipomo Garage and its accompanying bar, as well as a diner and a card room. Also shown are the old barbershop and a cabinet shop, which stands empty today. (Courtesy San Luis Obispo County.)

ADOBE BRICKS. On Saturday, February 15, 1964, the *Telegram Tribune* ran an article highlighting the adobe restoration. Alonzo P. Dana, who was present on the occasion, said he was born in the room pictured. The historical society made the adobe bricks sitting in the room prior to utilizing them in the restoration of the process. (Courtesy History Center of SLO County.)

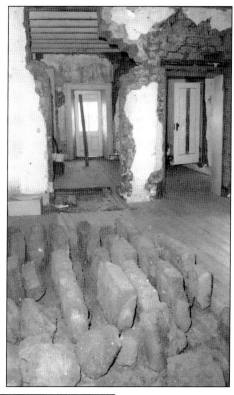

INSIDE THE LUCAS STORE. From left to right, Hazel Muñoz, Helen Dana, Edith Lucas, and George Dana enjoy one of the Easter celebrations at the Lucas Store next to an extremely well-decorated rabbit cake during the early 1960s. (Courtesy Jerry Knotts.)

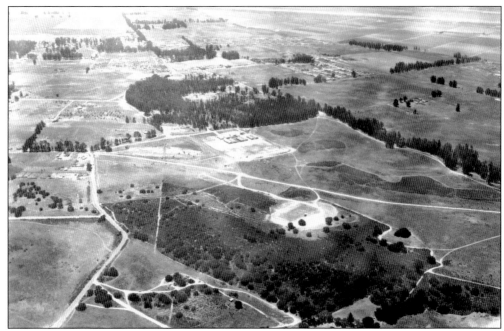

NIPOMO FROM ABOVE. In 1965, an aerial photograph captures the west end of Nipomo. Visible in the center of the photograph is Dana School. In the upper right is Galaxy Mobile Home Park. The rest of the mesa consists of empty fields and eucalyptus trees. (Courtesy History Center of SLO County.)

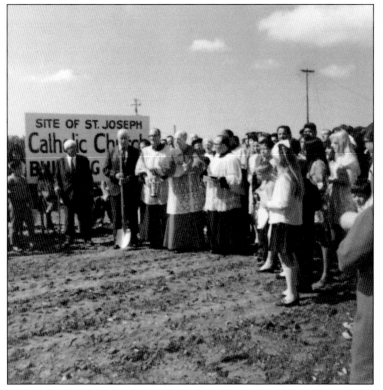

NEW CHURCH. The town's Catholic church, once located on the corner of Tefft and Thompson Streets across from Jocko's, outgrew its building. In 1968, the church constructed a new building at 298 South Thompson Street. Among the many unidentified people who attended the ground-breaking ceremony were local bishop Fr. Silvano Girolami, and Nipomo's first priest, who was associated with St. Patrick's Church in Arroyo Grande. (Courtesy Jerry Knotts.)

NIPOMO WOMEN'S CLUB. Because of technological advances following the Civil War, women around the nation had more free time and were able to form organizations for the advancement of society in the form of women's clubs. Initially these groups were organized as book clubs, but later they evolved and founded important institutions such as libraries and hospitals in their communities. Pictured here are women from the Nipomo Women's Club, including Peg Miller (center right) surrounded by other members of the club when she was inaugurated as president.

SENATOR A.A. ERHART. A crew visits the Dana Adobe. From left to right are Peter Andre, Mrs. Banning Garrett, Sen. A.A. Erhart, and Miles Fitzgerald in 1971. The group is surveying the grounds, no doubt finding some of the artifacts that still litter the Dana Adobe property today. Mrs. Banning Garrett was the first president of the Dana Adobe, while A.A. Erhart was a state senator. Formerly a county supervisor during the Great Depression, he took office in 1951 following the death of Sen. Chris Jesperson. (Courtesy History Center of SLO County.)

NIPOMO ADOBE DAYS. In October 1973, Nipomo's "Adobe Days" took place in an effort to raise funds for the restoration of the historical home. One of the festivities was a parade through Old Town. The Dana Adobe had a float in the parade (above) and local school marching bands participated in the event (below). Children dressed in costume and celebrated the town's history. (Both, courtesy Peg Miller.)

THE AMERICAN DREAM. Miguel Amezcua came to the United States in 1919 to avoid the violent Mexican Revolution that was taking place. He lost his first wife and daughter in the process, traveling with migrant farm workers until 1945, when he settled in the area. He worked on his own ranch while continuing to work in nearby fields to ensure that his second wife and family had a better quality life and education than he received. His second wife, Hermina, ran much of the ranch. She grew up on a ranch in Mexico and was able to apply her knowledge to the ranch in Nipomo. In 1974, the *Telegram-Tribune* covered Amezcua's story, capturing these photographs along the way. Catle Amezcua, his daughter, is quick to point out the family's proud heritage. As a child, the Dana family inspired Catle to take up quilting, which she still does today with her club, the Piggy Farm Quilters. The club meets in Old Town. (Both, courtesy Catle Amezcua.)

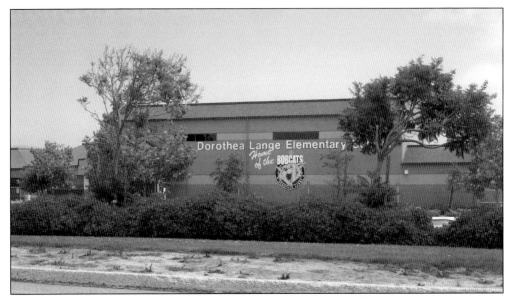

DOROTHEA LANGE ELEMENTARY SCHOOL. In 2006, Lucia Mar Unified School District built a new school in town. They chose to name it after the famous photographer that traveled through Nipomo, thereby keeping ties with the past. (Photograph by Rachel Jenzen.)

WILLOW ROAD EXTENSION. Similar to the ways in which Nipomo benefited from federal stimulus projects during the Great Depression, the town has benefited from the American Reinvestment and Recovery Act in the form of improved infrastructure. Money from various agencies added to the $1.7 million from the federal government, which helped to pay for the construction that began in 2010. The interchange will allow for easier access to the Nipomo Mesa and Highway 1. (Photograph by Doug Jenzen.)

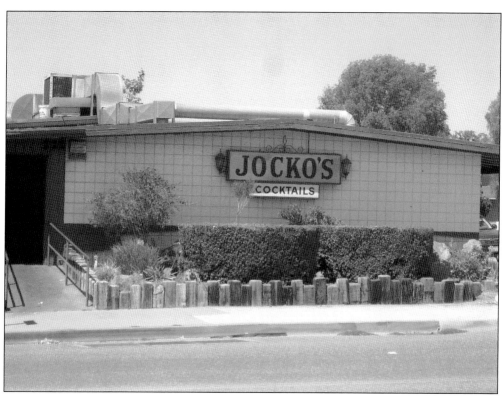

JOCKO'S. Anyone who is familiar with Nipomo has eaten at Jocko's Steakhouse. A local family establishment known for its servings of meat, bumper stickers advertising the restaurant with the "Follow Me to Jocko's" slogan can be found around the world. (Photograph by Doug Jenzen.)

QUINTESSENTIAL NIPOMO. A typical view of today's Nipomo consists of agriculture, the hills, and eucalyptus trees. Here, an antique windmill stands next to a eucalyptus tree among acres of strawberry fields. The famous hills tower in the background. Scenes such as this are the reason that many people move to Nipomo. (Photograph by Doug Jenzen.)

BIBLIOGRAPHY

Angel, Myron. *History of San Luis Obispo County With Illustration and Biographical Sketches of its Prominent Men and Pioneers*. Oakland, CA: Thompson & West, 1883.

Ardoin, Corrine. *A Natural History of the Nipomo Mesa Region*. Santa Maria, CA: C. Ardoin, 2004.

Casas, Maria Raquel. *Married to a Daughter of the Land: Spanish-Mexican Women and Interethnic Marriage in California: 182–1880*. Las Vegas, NV: University of Nevada Press, 2007.

Dana, Joseph L. *To Discourage Me Is No Easy Matter: The Life of California Pioneer William Goodwin Dana*. Arroyo Grande, CA: South County Historical Society, 2007.

Haggard, Ken. *San Luis Obispo Architecture: A Brief Architectural History of San Luis Obispo County*. San Luis Obispo, CA: Central Coast Press, 2008.

Hardee, Jim, and Dennis O. Flynn, Arturo Giraldez, and James Sobredo, ed. "Soft Gold: Animal Skins and the Early Economy of California." *Studies in Pacific History: Economics, Politics, and Migration*: 23–39. Burlington, VT: Ashgate, 2002.

Krieger, Dan. *San Luis Obispo County: Looking Backwards into the Middle Kingdom*. San Luis Obispo, CA: EZ Nature Books, 1990.

Morrison, Annie L. Stringfellow, and John H. Haydon. *History of San Luis Obispo County and Environs with Biographical Sketches of the Leading Men and Women of the County and Environs Who have been Identified with the Growth and Development of the Section from the Early Days to the Present*. Los Angeles, CA: Historic Record Company, 1917.

Starrs, Paul F., and Peter Goin. *Field Guide to California Agriculture*. Los Angeles, CA: University of California Press, 2010.

ABOUT THE ORGANIZATION

The Dana Adobe Nipomo Amigos (DANA) is a 501(c)3 nonprofit organization dedicated to the preservation, restoration, and operation of the Dana Adobe (California Historic Landmark No. 1033). DANA works to restore, interpret, and create education programs pertaining to the historical 38,000-acre Rancho Nipomo, including Nipomo, Los Berros, and the surrounding natural environment.

All author proceeds earned from the sales of this book will benefit DANA.

DISCOVER THOUSANDS OF LOCAL HISTORY BOOKS FEATURING MILLIONS OF VINTAGE IMAGES

Arcadia Publishing, the leading local history publisher in the United States, is committed to making history accessible and meaningful through publishing books that celebrate and preserve the heritage of America's people and places.

Find more books like this at
www.arcadiapublishing.com

Search for your hometown history, your old stomping grounds, and even your favorite sports team.

Consistent with our mission to preserve history on a local level, this book was printed in South Carolina on American-made paper and manufactured entirely in the United States. Products carrying the accredited Forest Stewardship Council (FSC) label are printed on 100 percent FSC-certified paper.

MADE IN THE